photographic lighting

essential skills

photographic lighting

third edition

john child
mark galer

AMSTERDAM • BOSTON • HEIDELBERG • LONDON • NEW YORK • OXFORD
PARIS • SAN DIEGO • SAN FRANCISCO • SINGAPORE • SYDNEY • TOKYO
Focal Press is an imprint of Elsevier

Focal Press
An imprint of Elsevier
Linacre House, Jordan Hill, Oxford OX2 8DP
30 Corporate Drive, Burlington MA 01803

First published 1999
Reprinted 2000
Second Edition 2002
Reprinted 2003
Third Edition 2005

British Library Cataloguing in Publication Data
A catalogue record for this book is available from the British Library

Library of Congress Cataloguing in Publication Data
A catalogue record for this book is available from the Library of Congress

ISBN 0 240 51964 7

For more information on all Focal Press publications visit our website at:
www.focalpress.com

Printed and bound in Italy

Working together to grow
libraries in developing countries
www.elsevier.com | www.bookaid.org | www.sabre.org

ELSEVIER BOOK AID International Sabre Foundation

Acknowledgements

Among the many people who have helped make this book possible, we wish to express our thanks to the following:

- ~ Michael Wennrich, Les Horvat and John Hay for their continuing support.
- ~ The students of RMIT University, Melbourne for their illustrative input, enthusiasm and friendship.
- ~ Our families for their love, encouragement and understanding.

Picture credits

Ansel Adams (CORBIS/Ansel Adams Publishing Trust); Spiro Alexopoulos; Paul Allister; Tim Barker; Kata Bayer; Shane Bell; Andrew Boyle; Rebecca Coghlan; Rachel Dere; Mick Downes; Samantha Everton; Joanne Gamvros; Martina Gemmola; Natarsha Gleeson; Wil Gleeson; Andrew Goldie; Shaun Guest; Orien Harvey; John Hay; Wil Hennesey; Itti Karuson; Tommy Kellner; Jana Liebenstein; Jacqui Melville; Michel McFarlaine; Line Mollerhaug; James Newman; Matthew Orchard; Fabio Sarraff; Janette Smith; Tim Stammers; Shivani Tyagi; Rebecca Umlauf, Charenjeet Wadwha; Michael Wennrich; Daniel Willmott; Stuart Wilson.

Technical illustrations (photographic) by Jana Liebenstein, Dianna Snape and Charenjeet Wadwha.
Illustrations by Mark Galer.
All other photographs are by the authors or from the RMIT Alumni Collection.

Contents

acquisition module>>

Contents

Contents

application module>>

ix

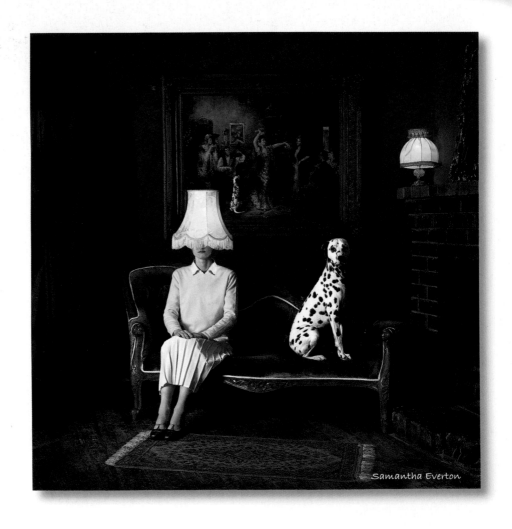

Samantha Everton

skill ac

acquisition module>>

quisition

Introduction

Lighting is the essential skill in photography. From the captured image of a fleeting moment using existing light to the highly structured and preconceived advertising image using introduced lighting. To understand and improve these skills this book deals with working on location, primarily using the existing light source, and in the studio using artificial light sources. The information, activities and assignments provide the essential techniques for creative and competent photography. The study guides offer a comprehensive and highly structured learning approach, giving both support and guidance. Basic theoretical information is included with an emphasis on useful practical advice that will maximise the opportunities for creative photography.

Itti Karuson

Acquisition and application of skills

This book concentrates on the acquisition and application of skills necessary for location and studio lighting. Emphasis is placed on image design, communication of content and the essential techniques required for competent and consistent image capture and creation. This increases competence to correctly expose film or digital image sensors under difficult lighting conditions. The practical problems of contrast are discussed and additional lighting in the form of flash and tungsten is introduced. Terminology is kept as simple as possible using only those terms in common usage by practising professionals.

Activities and assignments should be undertaken to allow students to express themselves and their ideas through the appropriate application of design and technique.

Introduction to teachers

This book is intended as an introduction to location and studio photography for full-time students. The emphasis has been placed upon a practical approach to the application of essential skills. The activities and assignments cover a broad range and it is possible to achieve acceptable results without the need for large amounts of expensive equipment.

A structured learning approach

The study guides contained in this book offer a structured learning approach forming the framework for working with photographic lighting and the essential skills for personal creativity and communication. They are intended as an independent learning source to help build design skills, including the ability to research, plan and execute work in a systematic manner. Students are encouraged to adopt a thematic approach, recording all research and activities in the form of a Visual Diary and Record Book.

Flexibility and motivation

The assignments contain a degree of flexibility, often giving the students the choice of subject matter. This allows the pursuit of individual interests whilst still directing work towards answering specific criteria. This approach allows the maximum opportunity to develop self motivation. It is envisaged that teaching staff will introduce each assignment and negotiate the suitability of subject matter with the students. Individual student progress should be monitored through group meetings and personal tutorials.

Students should be encouraged to demonstrate the skills which they have learnt in preceding study guides whenever appropriate.

Implementation of the curriculum

For full time students of photography this book provides a suitable adjunct to *Essential Skills: Studio Photography* and *Essential Skills: Location Photography.*

Web site

A dedicated web site exists to assist teachers with their usage of this book. Revision exercises are included on the site as are numerous links and up-to-date advice and references. The revision exercises should be completed sequentially and within a specified time. This process will enable students to organise their efforts and give valuable feedback about their strengths and weaknesses. The revision exercises should be viewed as another activity which the student resources and completes independently whilst being monitored. Students should then be encouraged to demonstrate the skills and knowledge they have acquired in the process of working through the activities and revision exercises by completion of a self-directed series of projects or all the assignments in the books *Essential Skills: Studio Photography* and *Essential Skills: Location Photography.* The internet address for the web site is: www.photoeducationbooks.com

Introduction to students

The study guides are designed to help you learn both the technical and creative aspects of photography. You will be asked to complete various tasks including research activities, revision activities and practical assignments. The information and experience you gain will provide you with a framework for all your future photographic work.

Activities and assignments

By completing all the activities, assignments and revision exercises you will learn how other images were created, how to create your own and how to communicate visually. The images you produce will be a means of expressing your ideas and recording your observations. Photography is a process best learnt in a series of steps. Once you apply these steps you will learn how to be creative and produce effective images. The study guides also explain many of the key issues which are confusing and often misunderstood - an understanding of which will reinforce and facilitate creative expression.

Using the study guides

The study guides have been designed to give you support during your photographic learning. On the first page of each is a list of aims and objectives identifying the skills covered and how they can be achieved. The activities are to be started only after you have first read and understood the supporting section on the preceding pages. At the end of each chapter the relevant revision exercise from the supporting web site should be undertaken to determine the extent to which the information has been assimilated. After completion of the activities and revision exercises the 'Assignments' should be undertaken. If you are unclear about what is being asked of you, consult a lecturer.

Equipment needed

The course has been designed to teach you photographic lighting with the minimum amount of equipment. You will need a camera with manual controls or manual override. However, large amounts of expensive equipment are not necessary to gain an understanding of the use of light. Observation of daylight, ambient light, normal household light globes, desk lamps, outdoor lighting, torches and small flash units can be adapted and utilised to produce acceptable results. Supplemented with various reflectors (mirrors, foil, white card) and assorted diffusion material (netting, cheesecloth, tracing paper, Perspex) a degree of lighting control can be achieved. Many of the best photographs have been taken with very simple equipment. Photography is more about understanding and observing light, and then recreating lighting situations to achieve form, perspective and contrast when working with a two-dimensional medium.

Gallery

At the end of each study guide is a collection of work produced with varying combinations of daylight, ambient light, flash and tungsten light sources, captured on film or image sensor and saved to digital file.

3

photographic lighting >>> essential skills >>>

Research and resources

To gain the maximum benefit from each assignment use the activities contained in the study guide as a starting point for your research. You will only realise your full creative potential by looking at a variety of images from different sources. Artists and designers find inspiration for their work in different ways, but most find that they are influenced by other people's work they have seen and admired. Further, it is essential the student of any creative endeavour has some understanding of the context of their art. Researching relevant artists and practioners is an essential element of this process.

Getting started

Collect images relevant to the activity you have been asked to complete. This collection of images will act as valuable resource for your future work. Do not limit your search to photographs. Explore all forms of the visual arts. By using elements of different images you are not copying but using the information as inspiration for your own creative output. Talking through ideas with other students, friends, family, lecturers or anyone willing to listen will help you clarify your thinking and develop your ideas.

Kata Bayer

Choosing resources

When looking for images, be selective. Use only high quality sources. Not all photographs are well designed or appropriate. Good sources may include high quality magazines and journals, photographic books, exhibitions and the web. You may have to try many various sources to find suitable material. In addition, be aware of exhibitions coming to your local galleries.

Visual Diary

A Visual Diary is a record of all visual and written stimuli influencing or forming the basis of an idea for the photographic assignments and practical work to be completed.

In its most basic form this could be a scrapbook full of tear sheets (examples) and personal scribbles. It would, however, be of far more value if your Visual Diary contained more detail relating to an increasing awareness of your visual development in discriminating between good and bad examples of location and studio lighting. This should include design, composition, form and light applicable to any visual art form.

Joanne Gamvros

The Visual Diary should contain:

~ A collection of work by photographers, artists, writers and filmmakers relevant to your photographic studies.

~ Web site addresses and links.

~ Sketches of ideas for photographs.

~ A collection of images illustrating specific lighting and camera techniques.

~ Brief written notes supporting each entry in the diary.

Record Book

The Record Book forms the documented evidence of the practical considerations and outcomes associated with the completion of each activity and assignment. It should contain comprehensive information enabling another photographer, who was not present at the original time of production, to reproduce the photograph. This is common professional practice.

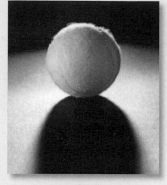

Ball	26/03/04
Film	Ektachrome 64T
Polaroid	Polapan Pro 100
Lighting ratio	Spotlight f64
	Floodlight f45
	Reflector f32
Meter reading	Incident 2 seconds f45
Polaroid exposure	3 seconds f45
Exposure	3 seconds f45
Process	Normal

Spotlight from back to create rim light. Floodlight from left, centre of light at point where front of ball falls into shadow. Creates gradual decrease in light across front. White reflector to right side of ball.

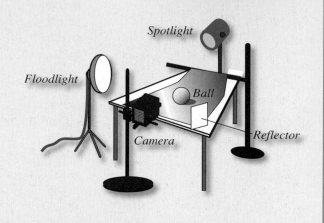

The Record Book should contain:

~ An information sheet for each activity and assignment.
~ Technical requirements and equipment used.
~ Lighting diagram, camera to subject diagram, camera angle and height (measurements and specifications).
~ Meter readings of light ratios and exposure.
~ Film or image sensor type, filtration, exposure, processing.
~ All Polaroids.
~ Any processed film or digital files used to reach the final result should be kept.
~ Props (use and source) and any other information relevant to each photograph.

Presentation

Research

In each assignment you are asked to provide evidence of how you have developed your ideas and perfected the techniques you have been using. This should be presented in an organised way showing the creative and technical development of the finished piece of work. Make brief comments about images that have influenced your work. Photocopy these images and include them with your research.

Practical work

Presentation of your practical work can have a major influence on how your work is viewed.
- ~ When presenting on-screen make sure the software and computer are compatible.
- ~ Ensure that all of your digital images are cropped neatly and do not display unwanted edge pixels.
- ~ Mount all printed work neatly and label appropriately.
- ~ Window mount transparencies in black card.
- ~ Ensure that horizontal and/or vertical elements are corrected if this is approporiate (sloping horizon lines are visually unnerving to look at).

Tommy Kellner

Storage

It is best to standardise your final portfolio so that it has an overall 'look' and style.
- ~ Assignments should be kept in a folder slightly larger than your mounted work.
- ~ Film should be stored in a dust - and moisture-free environment.
- ~ Digital files should be burned to a CD or saved to a portable disk or hard drive and stored away from magnetic devices that could corrupt the data.

Wil Hennesy

Orien Harvey

characteristics of light

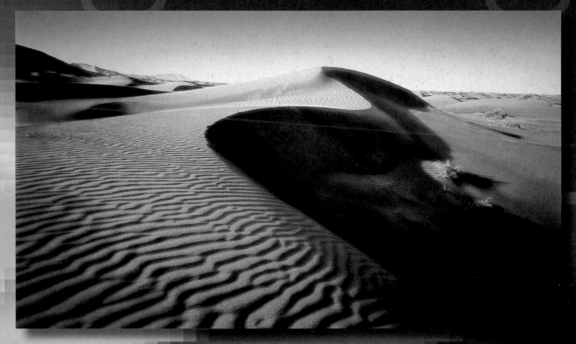

Mark Galer

essential skills

~ An understanding of how light changes the character and mood of an image.

~ An awareness of subject contrast and its effect upon film or image sensors.

~ Developing the skills to control introduced lighting on location and in the studio.

~ Creating images demonstrating how lighting techniques control communication.

~ Documenting the progress and development of your ideas.

Introduction

Light is the essence of photography. Without light there is no photography. Light is the photographer's medium. The word photography is derived from the ancient Greek words, '*photos*' and '*graph*', meaning 'light writing'. To understand light the photographer must be fully conversant with its qualities and behaviour. In mastering the medium the photographer learns to take control over the creation of the final image. This takes knowledge, skill and craftsmanship. It can at first seem complex and sometimes confusing. However, with increased awareness and practical experience light becomes an invaluable tool to communication.

Seeing light

In order to manage a light source, we must first be aware of its presence. Often our preoccupation with content and framing can make us oblivious to the light falling on the subject and background. We naturally take light for granted. This can sometimes cause us to simply forget to 'see' the light. When light falls on a subject it creates a range of tones we can group into three main categories: Highlights, Mid-tones and Shadows.

Each of these can be described by their level of illumination (how bright, how dark) and their distribution within the frame. These are in turn dictated by the relative position of Subject, Light source and Camera.

Image 1 - Shivani Tyagi *Image 2 - Rebecca Umlauf*

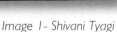

ACTIVITY 1

Describe the above images in terms of highlights, mid-tones and shadows.
Draw diagrams to indicate the relative position of subject, light source and camera.

Introducing light

The major difference between studio and location photography is the studio itself has no ambient or inherent light. The photographer starts with no light at all and has to previsualise how to light the subject matter and what effect that light will have upon the subject. Studio photographers have to conceive the lighting of the subject rather than observe what already exists. This requires knowledge, craft, observation, organisation and discipline. Good studio photography takes time, lots of time, and **patience.**

Mark Galer

Understanding the nature of light

In order to make the best use of an artificial light source, we must first be aware of how light acts and reacts in nature. Observation of direct sunlight, diffuse sunlight through cloud and all its many variations will develop an understanding of the two main artificial studio light sources available. A spotlight (point light source) imitates the type of light we see from direct sunlight, a hard light with strong shadows and extreme contrast. A floodlight (diffuse light source) imitates the type of light we see on an overcast day, a soft diffuse light with minor variations in contrast and few shadows. To understand light fully it is essential to examine its individual characteristics.

~ Source
~ Intensity
~ Quality
~ Colour
~ Direction
~ Contrast.

Source

Ambient

Ambient light is existing natural or artificial light present in any environment. Ambient light can be subdivided into four major categories:

~ Daylight
~ Tungsten
~ Fluorescent
~ Firelight.

Daylight

Daylight is a mixture of sunlight and skylight. Sunlight is the dominant or main light. It is warm in colour and creates highlights and shadows. Skylight is the secondary light. It is cool in colour and fills the entire scene with soft diffused light. Without the action of skylight, shadows would be black and detail would not be visible. Most colour films are calibrated to daylight at noon (5500K). When images are recorded at this time of the day the colours and tones reproduce with neutral values, i.e. neither warm nor cool.

Tungsten

A common type of electric light such as household bulbs/globes and photographic lamps. A tungsten element heats up and emits light. Tungsten light produces very warm tones when used as the primary light source with daylight film. Underexposure occurs due to the lack of blue light in the spectrum emitted. The orange colour cast can be corrected with a blue filter if neutral tones are desired; however, correct colour can be achieved without filtration if used with tungsten film. Digital cameras neutralise colour casts introduced by light sources other than daylight by adjustment of the white balance to the dominant light source or by capturing as RAW format and correcting in post production.

Fluorescent

Phosphors inside fluorescent tubes radiate light after first absorbing ultraviolet light from mercury vapour emission. The resulting light produces a strong green cast not apparent to the human vision. If used as a primary light source the results are often unacceptable due to the broad flat light and the strong colour cast. Underexposure is again experienced when using this light source and the cast can be difficult to correct. Fluorescent light flickers and causes uneven exposure with focal plane shutters. To avoid this shutter speeds slower than 1/30 second should be used.

Firelight

Light from naked flames can be very low in intensity. With very long exposures it can be used to create atmosphere and mood with its rich red tones.

Artificial light

Tungsten (non-domestic)

There are many variations of non-domestic tungsten light sources used in a photographic, film and Tv studios. They all fall into two major categories, floodlight and spotlight. The majority have a colour temperature of 3200 - 3400K and are compatible with tungsten colour film and any black and white film. A simple floodlight would have an output of 500 watts and a basic focusing spotlight around 650 watts.

Professional spotlights come with barn doors and nets. Barn doors are metal flaps used to control the shape and quantity of light falling on the subject. Nets are pieces of wire gauze of varying densities that reduce the quantity and alter the quality of the light by diffusing the light at its source. Similar items used to create the same effect when using a floodlight are known as cutters (shape and quantity) and various diffusion material (quantity and quality). See '**Studio Lighting**'.

Rebecca Coghlan

Flash (studio)

The main differences between location and studio based flash are size, cost and output. Studio flash is physically larger, costs a great deal more and produces a far greater output of light. As with tungsten lighting there are numerous flash equivalents of the two standard light sources, flood and spot. The majority have a colour temperature of 5500 - 5800K and are compatible with daylight and black and white film. Despite the names, swimming pool, soft box, fish fryer, honeycomb etc., these are really only large or smaller versions of a diffuse light source. The use of an open flash (direct light to subject without diffusion) will give the same effect as a spotlight. Most brands have focusing capabilities and the range of attachments available for tungsten exist in one form or another for use with flash. See '**Studio Lighting**'.

ACTIVITY 2

Research the cost and availability of photographic light sources (tungsten and flash), stands and associated equipment. Research any low cost lighting alternatives not specifically designed for photographic needs. Compare their output, measured in watts, and cost.

Intensity

Light intensity is a description of the level of a light's brightness. The intensity of light falling on a subject can be measured using a light meter. This is called an '**incident reading**'. A light meter built into a camera does not directly measure the intensity of light falling on the subject but the level of light reflected from it. This is called a '**reflected reading**'.

Itti Karuson

Reflectance

Regardless of the intensity of the light falling on the subject, different levels of light will be reflected from the subject. The amount of light reflecting from a surface is called '**subject reflectance**'. The levels of reflectance vary according to the colour, texture and angle of the light to the subject. A white shirt will reflect more light than a black dress. A sheet of rusty metal will reflect less light than a mirror. In all cases the level of reflectance is directly proportional to the viewpoint of the camera. If the viewpoint of the camera is equal to the angle of the light to the subject the reflectance level will be greater. The level of reflected light is therefore determined by:

~ Reflectance of the subject.
~ Intensity of the light source.
~ Angle of viewpoint and light to subject.
~ Distance of the light source from the subject.

Although the intensity of the light source may remain constant (such as on a sunny day) the level of reflected light may vary.

photographic lighting

>>>

>>> essential skills >>>

Fall-off

As the distance between the subject and the light source increases the level of light illuminating the subject decreases. The amount of light falling on a subject decreases to 25% of its original intensity when the light to subject distance is doubled. This change in the level of illumination is called fall-off and is quantified by the 'Inverse square law'.

For example, if a reading of f16 is obtained when the light to subject distance is one metre, at two metres the reading would be f8, at four metres f4. These rules do not change regardless of the light source. Although fall-off does not present a problem when working with direct sunlight (all subjects being the same distance from the sun), it does need to be considered with reflected light, window light and artificial light sources. The visual effect of subjects at differing distances to the light source is uneven illumination.

Inverse square law

When a surface is illuminated by a point source of light the intensity of the light at the surface is inversely proportional to the square of its distance from the light source.

Light fall-off - Itti Karuson

ACTIVITY 3

Using a floodlight or window light, illuminate two people standing at one and two metres from the light source.

Position the people two metres further away from the light source so that the people are now three and four metres from the light source.

Does the difference in brightness between the two people illuminated by the light source increase or diminish as the light source moves further away from the subjects?

Quality

Light from a point light source such as an open flash or the sun is described as having a 'hard quality'. The directional shadows created by this type of light are dark with well-defined edges. The shadows created by the sun are dark but not totally devoid of illumination. This illumination is provided by reflected skylight. The earth's atmosphere scatters some of the shorter blue wavelengths of light and provides an umbrella of low-level light. Artificial point light sources create a much harsher light when used at night or away from the softening effects of skylight. The light from a point light source can also be diffused, spread or reflected off larger surface areas. Directional light maintains its 'hard quality' when reflected off a mirror surface but is scattered in different directions when reflected off a matte surface. This lowers the harshness of the light and the shadows now receive proportionally more light when compared to the highlights. The light is said to have a softer quality. The shadows are less dark (detail can be seen in them) and the edges are no longer clearly defined.

Harsh light - Kata Bayer *Soft light - Fabio Sarraff*

The smaller the light source, the harder the light appears.
The larger the light source, the softer the light appears.

The control over quality of light is an essential skill when on location. Often the photographer will encounter scenes where the quality of the ambient light creates enormous difficulties for the latitude of the film or image sensors latitude. The photographer must learn techniques to alter the quality of light or risk loss of detail and information. The quality of light, whether hard or soft, can be changed by diffusion and reflection.

Diffusion

A light source can be diffused by placing certain materials between the light source and the subject. This has the effect of diffusing and spreading the light over a greater area by artificially increasing the size of the source. Relative to its size, the further the diffusion material from the light source the larger the light appears to be. This softens the shadows, increases shadow detail and decreases the measured amount of light falling on the subject.

Jacqui Melville

Reflection

Light is reflected off surfaces to varying degrees. More light will be reflected off silver than off black. Reflection is a simple way of changing the quality of light. The amount of light reflected off a surface is directly related to subject contrast. A point source of light will give hard shadows to the left side of a subject when lit from the right. This is called high contrast as there are only highlights and shadows. A reflector used to reflect the light passing the subject back onto the left side would reduce the contrast by raising the detail in the shadows to a level closer to the highlights.

ACTIVITY 4

Illuminate a subject with a range of tones (another person) under many varied light sources. Include daylight, domestic lighting, street lighting, commercial and industrial lighting and light sources in your studio.

Observe how the quality of the light varies from light source to light source and the differences in the reflective levels of elements in the photographs.

Modify the quality of a light source by placing a diffusing material between the light source and the subject. Observe the differences in the highlights and shadows.

Colour

The visible spectrum of light consists of a range of wavelengths from 400 nanometres (nm) to 700nm. Below 400nm is UV radiation and X-rays and above 700nm is infrared (all capable of being recorded photographically). When the visible spectrum is viewed simultaneously we see 'white light'. This broad spectrum of colours creating white light can be divided into the three primary colours: **red, green and blue.** The precise mixture of primary colours in white light may vary from different sources. The light is described as cool when predominantly blue, and warm when predominantly red. Human vision adapts to different mixes of white light and will not pick up the fact a light source may be cool or warm unless compared directly with another in the same location.

The light from tungsten bulbs and firelight consists predominantly of light towards the red end of the spectrum. The light from tungsten-halogen and photoflood lamps is also predominantly light towards the red end of the spectrum. The light from AC discharge and flash consists predominantly of light towards the blue end of the spectrum. Daylight is a mixture of cool skylight and warm sunlight. Image sensors and film balanced to 'Daylight' will give fairly neutral tones with noon summer sunlight. When the direct sunlight is obscured or diffused, however, the skylight can dominate and the tones record with a blue cast. As the sun gets lower in the sky the light gets progressively warmer and the tones will record with a yellow or orange cast.

The colour of light is measured by colour temperature, usually described in terms of degrees Kelvin (K). This scale refers to a colour's visual appearance (red - warm, blue - cold).

Colour correction

When using a digital camera and saving to JPEG or TIFF colour correction is achieved by adjusting the white balance to the dominant light source. Alternatively save to camera RAW format and correct in post production.

Note > To avoid small inconsistencies of colour reproduction it is not recommended to use Auto White balance when using a print service provider to print from a batch of images shot using the same light source.

To control the colour of the final image when shooting film the photographer has the option to choose the time of day or use filters to reduce or remove the colour cast when using film. Tungsten film is rated at 3200K. Daylight film is rated at 5500K. Filtration can be used to balance any film to any lighting situation. The filtration required to correct most common light sources is listed in the manufacturer's specifications packaged with the film. Comprehensive lists are available from the film or filter manufacturer.

ACTIVITY 5

Observe the effects of viewing a subject illuminated by tungsten light through a blue filter, gel or coloured acetate.

Attach red, green and blue filters to three torches of the same type and size.

Adjust the beams so they overlap, making notes of the new colours created.

What is the colour where all three beams intersect?

Discuss what factors may influence the accuracy of this experiment.

Colour correction - RAW

All digital cameras capture in RAW but only the medium - to high-end cameras offer the user the option of saving the images in this RAW format. Selecting the RAW format in the camera stops the camera from processing the colour data collected from the sensor when each image is captured. Digital cameras typically process the sensor's colour data by applying the white balance, sharpening and contrast settings set by the user in the camera's menus. Selecting the RAW format prevents this image processing taking place. The RAW data is what the sensor 'saw' before the camera processes the image and many photographers have started to refer to, and use, this file as the 'digital negative'.

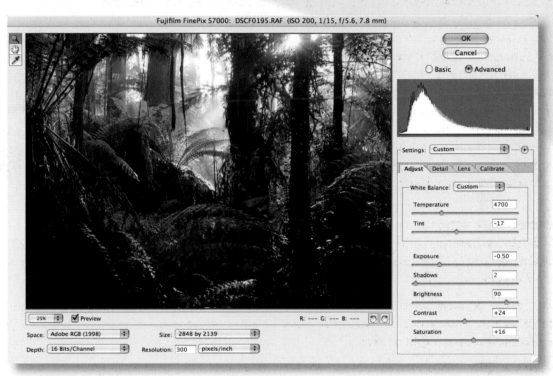

Working with a camera RAW editor

To harness the full power and functionality of the RAW format, a dedicated RAW editor is required. Whilst many standalone versions of such software are available, Adobe released a plug-in (known as camera RAW) for Photoshop 7 in 2003, which is now fully integrated into the latest version of Photoshop CS. To retain the white balance setting as originally selected in the camera at the time of capture, click the '**As Shot**' option in Photoshop's camera RAW dialog box. However, if it is felt that changes need to be made to these parameters, they can easily be achieved by use of the '**Temperature**' and '**Tint**' sliders. In particular, moving the Temperature slider to the left shifts the colors to the blue end of the spectrum to compensate for a yellowish cast resulting from an image created with a light source of low colour temperature. Similarly moving the slider to the right will compensate for a high original colour temperature by adjusting the image in the yellow direction. The Tint slider enables further fine-tuning in the green/magenta directions, which are most commonly needed for images captured under flourescent lighting envirinoments.

photographic lighting >>> >>> essential skills >>> >>>

White Balance tool

Another method of selecting white balance is achieved with the use of the **White Balance** tool found in the top right corner of the RAW dialog box. If a neutral or 'desaturated' tone is selected in the image window using the White Balance tool, an automatic colour correction is performed. Photographers can place a neutral tone such as a grey card or Macbeth colour checker into the first image of a shoot for just this purpose. The white balance settings for this image can then be saved and applied to all other images shot in the same lighting conditions as part of a 'batch processing' procedure.

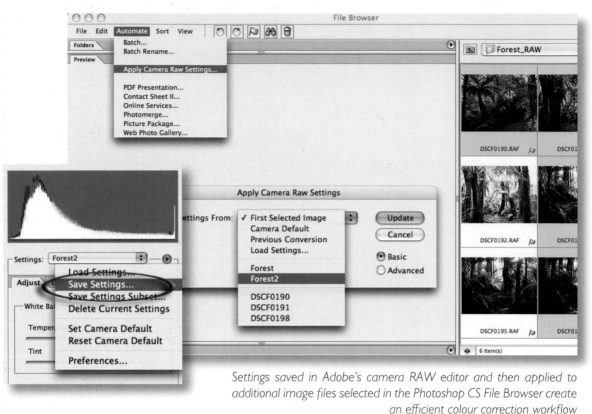

Settings saved in Adobe's camera RAW editor and then applied to additional image files selected in the Photoshop CS File Browser create an efficient colour correction workflow

Batch processing - adopting a RAW workflow

Due to the comparatively slow processing of RAW files Adobe has come up with a RAW workflow that allows the automatic processing of a collection of image files that require the same adjustments. Any settings applied to an individual camera RAW file can be saved and used to process additional files. The ability to process a batch of images in Photoshop is particularly useful when additional images from the same capture device and captured under the same lighting conditions would benefit from the same settings applied. Using the File Browser in Photoshop CS the user has the ability to apply the settings to the image previews without having to actually open each image. When the image selection is complete the user can then simply instruct Photoshop to process all of the selected images and open them into Photoshop with the required settings. It is also possible using the File Browser to instruct Photoshop to generate contact sheets, PDF presentations or web galleries from these manged RAW files.

photographic lighting >>> >>>

essential skills >>> >>

Colour correction - film

Light source	Colour temperature	Film	Filter	Exposure
Average shade	8000K	Daylight	81EF	+0.65
		Tungsten	85B	+0.65
Overcast sky	7000K	Daylight	81D	+0.65
		Tungsten	85B	+0.65
Lightly overcast sky	6000K	Daylight	81A	+0.35
		Tungsten	85B	+0.65
Flash	5800K	Daylight	None	
		Tungsten	85B	+0.65
AC Discharge	5600K	Daylight	None	
		Tungsten	85B	+0.65
Daylight	5500K	Daylight	None	
		Tungsten	85B	+0.65
Early morning late afternoon	3500K	Daylight	82C	+0.65
		Tungsten	81B	+0.35
Photoflood	3400K	Daylight	80B	+1.65
		Tungsten	None	
Tungsten-halogen	3200K	Daylight	80A	+2.00
		Tungsten	None	
Domestic globes	2800K	Daylight	80A	+2.00
		Tungsten	82C	+0.65
Sunset	2000K	Daylight	80A	+2.00
		Tungsten	82C+82C	+1.35
Candle flame	1850K	Daylight	80A	+2.00
		Tungsten	82C+82C	+1.35
Match flame	1700K	Daylight	80A	+2.00
		Tungsten	82C+82C	+1.35

Direction

In the studio

The direction of light determines where shadows fall and their source can be described by their relative position to the subject. Shadows create texture, shape, form and perspective. Without shadows photographs can appear flat and visually dull. A subject lit from one side or behind will not only separate the subject from its background but also give it dimension. A front-lit subject may disappear into the background and lack form or texture. In nature the most interesting and dramatic lighting occurs early and late in the day. Observing and adapting these situations is a starting point to studio lighting.

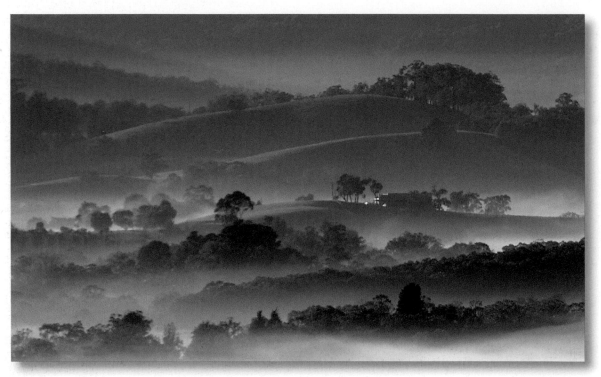

Mark Galer

On location

Many location photographs look flat and uninteresting. Photographers arriving at a location when the sun is high find a flat, even illumination to the environment. The colours can look washed out and there is little or no light and shade to create modelling and texture. The mood and atmosphere of a location can be greatly enhanced by the realisation that most successful location images are taken when the sun is low, dawn or dusk, or as it breaks through cloud cover to give uneven and directional illumination. When the sun is high or diffused by cloud cover the mood and the subject contrast usually remain constant. When the sun is low the photographer can often choose a variety of moods by controlling the quantity, quality and position of shadows within the image. Colours are often rich and intense and morning mists can increase the mood dramatically.

22

Contrast

Contrast is the degree of difference between the lightest and darkest tones of the subject or photographic image. A high-contrast photograph is one where dark tones and bright tones dominate over the mid-tones within the image. The highest contrast image possible is one containing only two tones, black and white, and where no mid-tones remain. A low-contrast image is one where mid-tones dominate the image and there are few if any tones approaching white or black.

Without contrast photographic images would appear dull and flat. It is contrast within the image that gives dimension, shape and form. Awareness and the ability to understand and control contrast is an essential skill to work successfully in the varied and complex lighting situations that arise on location and in the studio.

High contrast - Itti Karuson *Low contrast - Line Mollerhaug*

Affecting contrast

Contrast is affected by the difference in the intensity of light falling on a subject and the intensity this light reflects back to the viewer or light-sensitive surface. Light usually strikes three-dimensional subjects unevenly. Surfaces facing the light receive full illumination, whilst surfaces turned away from the light receive little or none. Different surfaces reflect different amounts of light. A white shirt reflects more light than black jeans. The greater the difference in the amount of light reflected, the greater the subject contrast. When harsh directional light illuminates a subject overall contrast increases. The highlight tones facing the light source continue to reflect a high percentage of the light whilst the dark tones in the shadows may reflect little. The difference between the darkest and the lightest tones increases, leading to increased contrast.

photographic lighting

>>>

Limitations of the medium

The human eye can register detail in a wide range of tones simultaneously. Film and digital image sensors are unable to do this. They can record only a small range of what human vision is capable of seeing. The photographer has the option of recording a selected range of tones or seek ways of lowering the contrast. In an attempt to visualise how the contrast of a subject will be translated by the photographic medium, many photographers use the technique of squinting or narrowing the eyes to view the scene. Squinting removes detail from shadows and makes the highlights stand out. In this way it is possible to estimate the contrast of the resulting image.

Contrast on location

Cloud cover diffuses the light, leading to lower contrast images. Shadows appear less harsh and with softer edges. The lighting may be described as being flat and the film or digital image sensor will usually be able to record the range of tones present if accurately exposed. When direct sunlight strikes the subject the contrast usually exceeds the film or image sensor's capability to record the range of tones. The photographer may have to seek a compromise exposure.

Fabio Sarraff

Creating contrast

Working in a studio situation, where the subject and lighting are under the control of the photographer, contrast is usually by design rather than by any error of judgement. As all the elements that cause contrast are controlled by the photographer it can be created and used to great effect. Placing highlights in shadow areas and deep shadows through mid-tones can create interesting images.

Revision exercise

Complete the Revision exercises relevant to this chapter.
They should be completed sequentially and within a specified time.
The internet address for the web site is: www.photoeducationbooks.com

Wil Hennesy

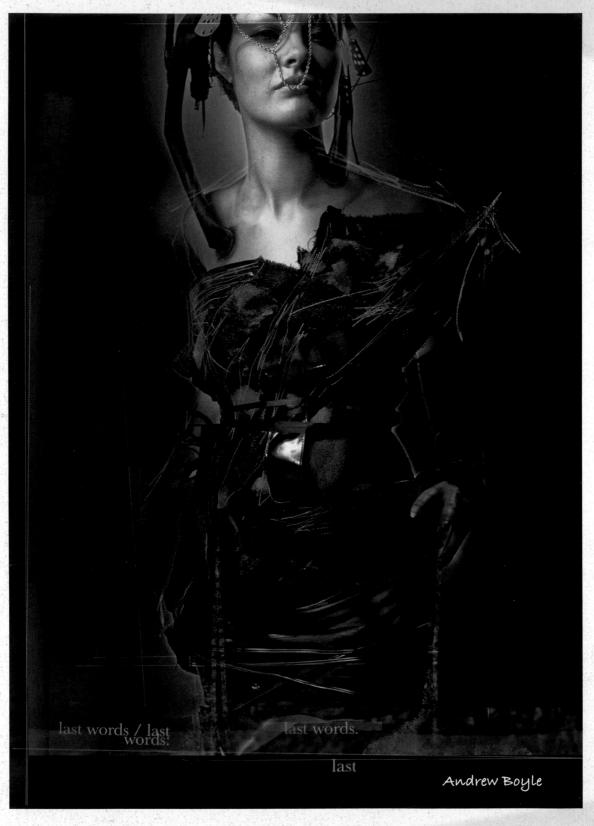

last words / last words:

last words.

last

Andrew Boyle

exposure and light meters

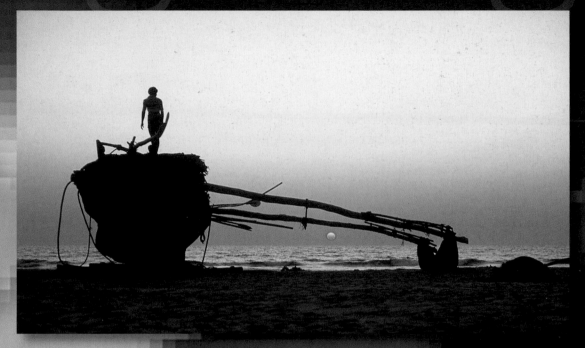

Mark Galer

essential skills

~ Gain a knowledge and understanding of exposure and its relationship to light sensitive surfaces, depth of field and selective focus.

~ Understand the use of hand-held and TTL light meters.

~ Understand the difference between reflected and incident meter readings and their relationship to lighting ratios and exposure.

~ Create images demonstrating an understanding of metering techniques.

~ Document the progress and development of these skills.

Introduction

An understanding of exposure is without doubt the most critical part of the photographic process. Automatic exposure systems found in many sophisticated camera systems calculate and set the exposure for the photographer. This may lead some individuals to think there is only one correct exposure, when in reality there may be several. The exposure indicated by an automatic system, no matter how sophisticated, is an average. Creative photographers use indicated meter readings for guidance only. Other photographers may interpret the same reading in different ways to create different images. It is essential the photographer understands how the illuminated subject is translated by exposure into a photographic image.

Exposure

Exposure is the action of subjecting a light-sensitive medium to light. Cameras and lenses control the intensity of light (aperture) and the duration of light (time) allowed to reach the film or image sensor. The intensity of light is determined by the size of the aperture in the lens and the duration of light is determined by the shutter.

Exposure is controlled by aperture and time - intensity and duration.

Too much light will result in overexposure. Too little light will result in underexposure. It makes no difference whether there is a large or a small amount of light, the film or image sensor still requires the same amount of light for an appropriate exposure.

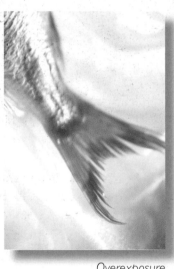
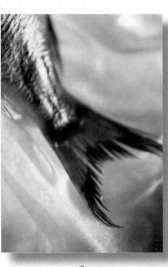
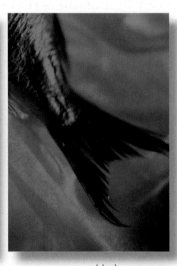

Overexposure *Correct exposure* *Underexposure*
- Line Mollerhaug

Film, unlike image sensors, cannot alter its sensitivity to light. Exposure must be adjusted to compensate for these changes. This is achieved by adjusting either the intensity (**aperture**) or duration of light (**time**) or a film of a higher or lower ISO chosen. Increasing the size of the aperture gives more exposure, decreasing gives less. Decreasing the duration of the shutter speed reduces exposure, increasing gives more.

Measuring light

To calculate correct exposure the intensity or level of light has to be measured. Light is measured by a light meter. Understanding the metering techniques of both hand-held light meters and those found in most cameras using their own metering systems is an important skill. All light meters inform the photographer of the amount of light available to obtain an appropriate exposure. This information can be used to set aperture and shutter speed settings in a variety of combinations. Each combination will give different visual outcomes whilst retaining the same overall exposure (depth of field and motion blur). Working in a creative medium such as photography '**correct exposure**' can sometimes be a very subjective opinion. The photographer may want the image to appear dark or light to create a specific mood.

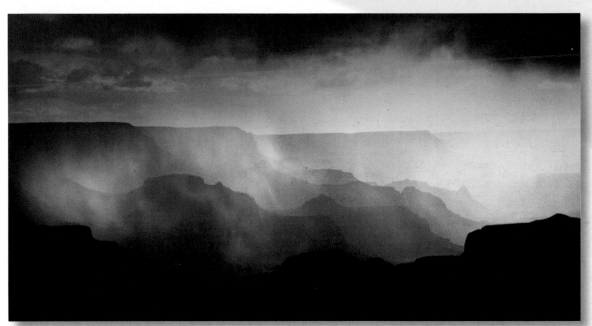

Exposing for highlights - Mark Galer

Appropriate exposure

A light meter reading should only be viewed as a guide to exposure. Film and digital image sensors are unable to record the broad range of tones visible to the human eye. If the camera frames a subject with highlights and shadows the light-sensitive medium may only be able to capture the highlight tones or the shadow tones, not both. An extremely bright tone and an extremely dark tone cannot both record with detail and texture in the same framed image. Underexposure and overexposure in one image is therefore not only possible but common.

It is often necessary for the photographer to take more than one reading to decide on the most appropriate exposure. If a reading is taken of a highlight area the resulting exposure may underexpose the shadows. If a reading is taken of the shadows the resulting exposure may overexpose the highlights. The photographer must therefore decide whether highlight or shadow detail is the priority, change the lighting or reach a compromise. A clear understanding of exposure is essential if the photographer is to make an informed decision.

Intensity and duration

Intensity

Light intensity is controlled by the aperture in the lens. Actual aperture is the size of the diameter of the iris built in to the camera lens. The aperture is a mechanical copy of the iris existing in the human eye. The human iris opens up in dim light and closes down in bright light to control the amount of light reaching the retina. The aperture of the camera lens must also be opened and closed in different brightness levels to control the amount or intensity of light reaching the film or image sensor. The right amount of light is required for correct exposure. Too much light and the light-sensitive medium will be overexposed, not enough light and it will be underexposed.

As the aperture on the lens is opened or closed a series of clicks can be felt. These clicks are called f-stops and are numbered. When the value of the f-stop **decreases** by one stop exactly **twice** as much light reaches the film or image sensor as the previous number. When the value of the f-stop **increases** by one stop **half** as much light reaches the film or image sensor as the previous number. The only confusing part is that maximum aperture is the f-stop with the smallest value and minimum aperture is the f-stop with the largest value. The larger the f-stop the smaller the aperture. Easy!

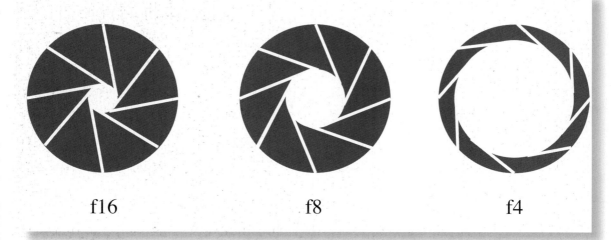

f16 f8 f4

ACTIVITY 1

Carefully remove the lens from either a small-format or medium-format camera.

Hold the lens in front of a diffuse light source of low intensity.

Whilst looking through the lens notice how the size of the aperture changes as you alter the f-stop.

Record and discuss the relationship between the size of the aperture and the corresponding f-stop number displayed on the barrel of the lens or in the LCD panel.

Relationship between aperture and f-number

The reasoning behind the values given to the f-stops can be explained by the following example:

~ The diameter of a selected aperture on a standard 50mm lens for a 35mm camera
 measures 12.5mm.
~ This measurement divides into the focal length of the lens (50mm) exactly four times.
~ The aperture is therefore given the number f4.
~ The diameter of another selected aperture on the same lens measures 6.25mm.
~ This measurement can similarly be divided into the focal length of the lens to give
 an f-number of f8, thereby explaining why the higher f-numbers refer to the smaller
 apertures.

Itti Karuson

The diameter of the same f-number may vary for different focal-length lenses but the intensity of
light reaching the image plane remains constant. F4 on a long focal-length lens is physically much
larger than the same aperture on a shorter focal length lens. The intensity of the light striking the
film or image sensor is the same, however, due to the increased distance the light has to travel
through the longer focal-length lens. See 'Inverse square law'.

ACTIVITY 2

Take exposure readings of a subject in bright sunlight and in deep shade. Record all of the
different combinations of exposure for each lighting condition. Compare the results between a
fixed focal length-lens and a zoom lens.

Duration

Light duration is controlled by the shutter. The time the light-sensitive surface is exposed to light is measured in whole and fractions of a second. This time is regulated by the shutter speed. Until the invention of the focal plane shutter, exposure time had been controlled by devices either attached to or within the lens itself. These shutters regulated the length of exposure. Early cameras had no shutter at all and relied upon the photographer removing and replacing a lens cap to facilitate correct exposure times. Other rudimentary shutters, very similar in appearance to miniature roller blinds, were tried but it was not until the invention of a reliable mechanical shutter that exposure times could be relied upon. As film emulsions became faster (increased sensitivity to light) so did the opportunity to make shorter exposures. Within a relatively brief period exposures were no longer in minutes but in fractions of a second.

Mark Galer

The shutter

The main types of shutter systems used in photography are the digital shutter, the leaf shutter and the focal plane shutter. The primary function of all systems is exposure. When the shutter is released it opens for the amount of time set on the shutter speed dial or LCD. These figures are in whole and fractions of seconds. The length of time the shutter is open controls the amount of light reaching the image plane. Each shutter speed doubles or halves the amount of light entering the camera.

Leaving the shutter open for a greater length of time will result in a slower shutter speed. Shutter speeds slower than 1/60 second, using a standard lens, can cause motion blur or camera shake unless you brace the camera or mount it on a tripod.

Using a shutter speed faster than 1/250 or 1/500 second usually requires a wide aperture, more light or a film or image sensor of increased sensitivity. These measures are necessary to compensate for the reduced amount of light passing through a shutter open for a short period of time.

> **The same exposure or level of illumination can be achieved using different combinations of aperture and shutter speed. For example, an exposure of f11 @ 1/125 second = f8 @ 1/250 second = f16 @ 1/60 second, etc.**

Digital shutter

The duration of the exposure can be controlled entirely by electronic means by switching on and switching off the image sensor for the prescribed amount of time. Many digital SLR cameras, however, use a hybrid system of digital and focal plane shutters.

Leaf shutter

Leaf shutters are situated in the lens assembly of most medium-format and all large-format cameras. They are constructed from a series of overlapping metal blades or leaves. When the shutter is released the blades swing fully open for the designated period of time.

Focal plane shutter

A focal plane shutter is situated in the camera body directly in front of the image plane (where the image is focused), hence the name. This system is used extensively in 35mm SLR cameras and a few medium-format cameras. The system can be likened to two curtains, one opening and one closing the shutter's aperture or window. When the faster shutter speeds are used the second curtain starts to close before the first has finished opening. A narrow slit is moved over the image plane at the fastest shutter speed. This precludes the use of high speed flash. If flash is used with the fast shutter speeds only part of the frame is exposed.

The advantages of a focal plane shutter over a leaf shutter are:

~ fast shutter speeds in excess of 1/1000 second;
~ lenses are comparatively cheaper because they do not require shutter systems.

The disadvantage is:

~ limited flash synchronisation speeds.

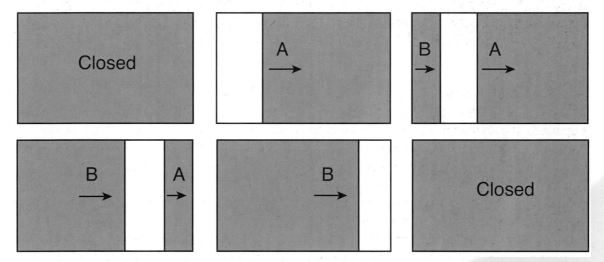

Focal plane shutter firing faster than the fastest flash synchronisation speed

ACTIVITY 3

Create exposures of a stationary subject at a variety of shutter speeds between 1/125 and 1/4 second whilst hand holding a camera. Use a standard focal length lens and correct the exposure using the aperture each time the shutter speed is adjusted.

Compare and discuss your results to see who has the least image blur.

Take exposure readings of a subject in bright sunlight and covered shade.

Record all of the different combinations of exposure for each lighting condition.

Hand-held light meters

Accurate exposure is critical to the final quality of the photographic image. It is therefore essential to have a reliable light meter. The ability of the human eye to compensate for variations in light, shade and contrast is far greater than any light-sensitive surface currently available. It is difficult to appreciate how the difference between dark and light tones and the balance between different light sources (lighting ratio) will translate into a photographic image without the use of a meter. Next to a camera the light meter is often considered the most important piece of photographic equipment. Most 35mm cameras and some medium-format cameras have built-in metering systems measuring light reflected from the subject. Although very useful, reflected light meters do not provide information to the photographer about the levels of light falling on the subject. Photographers requiring this information need a separate hand-held meter that will measure reflected and incident light. Without a meter only experience will tell you if there will be detail in the shadows or highlights when the film or image sensor is exposed.

Meter readings

Measuring light for the purpose of exposure can be achieved by taking a reflected or an incident reading.

A **reflected reading** is when the light-sensitive cell of the meter is pointed at the subject and the light reflected from the subject is measured.

An **incident reading** is when the meter's light-sensitive cell is pointed at the camera from the subject and the light falling on the subject is measured. A white plastic diffuser called an '**invercone**' is placed over the meter's light-sensitive cell. The invercone collects the light from a wide angle of view (180°) and transmits 18% of that light to the meter's cell.

Meter indicated exposure

The indicated exposure reading is known as the '**meter indicated exposure**' **(MIE)**.

Although the photographer sees a subject, the meter sees only a level of light. The meter is calibrated to render everything as a mid-tone regardless of the level of illumination. A meter will therefore give 'correct' exposure for a man in a grey flannel suit whether he is in a cellar or sunlight.

18% grey card

The mid-tone to which all meters are calibrated is called an '**18% grey card**', so called because it reflects 18% of the light falling upon it. It is an exposure and colour standard manufactured by Kodak. If a meter reading is taken from any single tone the resulting MIE will render the tone as a mid-tone. If a reflected meter reading is taken from a black card the resulting MIE will render the black card grey. If a reflected meter reading is taken from a white card the resulting MIE will render the white card grey. This is why snow often comes out grey in many snapshots.

Taking a hand-held meter reading

Incident reading

For an incident reading it is important to place the white plastic dome supplied with the meter over the light-sensitive cell. This is called an '**invercone**'. The purpose of the invercone is to diffuse the light falling on the subject from a wide angle of acceptance (180°) and transmit 18% of that light. The sensitivity or ISO of the film or digital image sensor must then be calibrated into the meter. The light meter is generally taken to the subject and the light-sensitive cell is directed back towards the camera. The reading may default to EV (exposure value), which can be interpreted or changed to an aperture/shutter speed combination. On modern digital meters the photographer is able to pre-select a particular shutter speed or aperture and have the meter indicate the corresponding value to obtain correct exposure.

Matthew Orchard

ACTIVITY 4

Take an incident light reading of a subject in a constant light source.

Note the f-stop at an exposure time of 1/8 second. Increase the number of the aperture by three f-stops.

Note the change in exposure time.

Discuss with other students what the result would be if the duration of time had been increased by a factor of three instead of the aperture.

Reflected reading

For a reflected reading it is important to remove the invercone. The meter's cell has an angle of acceptance equal to a standard lens (with a spot meter attachment the angle can be reduced to five degrees or less for precise measurements). The film or image sensor's ISO setting is calibrated into the meter. The meter is pointed **towards** the subject. The exposure the meter recommends is an average of the reflected light from the light and dark tones present. When light and dark tones are of equal distribution within the field of view this average reading is suitable for exposure. It must be remembered the meter measures only the level of light. It does not distinguish between dark or light tones. If a reading is taken from a single tone the light meter will always indicate an exposure suitable to render this tone as a mid-tone. If the subject is wearing a grey flannel suit a reflected reading from the camera would give an average for correct exposure. However, if the subject is wearing a white shirt and black jeans a reflected reading of the shirt would give an exposure that would make the shirt appear grey and a reflected reading of the jeans would also make them appear grey on film or digital image. When light or dark tones dominate the photographer must increase or decrease exposure accordingly.

General reflected reading

If the reading is taken from the camera position a general reading results. This general reading is an average between the reflected light from the light and dark tones present. When light and dark tones are of equal distribution within the frame this average light reading is suitable for exposing the subject. When light or dark tones predominate in the image area they overly influence the meter reading and the photographer must increase or decrease exposure accordingly.

Specific reflected reading

A more accurate reading can be taken when light or dark tones dominate the scene by moving the light meter closer to a mid-tone. This avoids the meter being overly influenced by the shadow and highlight tones. Care must be taken not to cast your own shadow or that of the meter when taking a reading from a close surface.

If the photographer is unable to approach the subject being photographed, it is possible to take a meter reading from a tone close to the camera. A useful technique is to take a reading from a grey card angled to reflect the same light as the subject or of Caucasian skin (approximately one stop brighter than a mid-tone).

Charanjeet Wadwha

Understanding the meter reading

There are many ways of understanding the information a light meter is giving in relation to exposure. The meter read-out system itself can be confusing. Some photographers refer to EV (exposure value) readings, others t-stops (transmission) and others in zones. In reality they all mean the same. Of all the variations the most common usage is f-stops. All meters usually default to f-stops and all camera lens apertures are calibrated in f-stops. It is important to understand if the exposure is increased by one stop, either by time or aperture, the amount of light entering the camera has doubled (2x). If increased by two stops the amount of light has doubled again (4x). If increased by three stops the light doubles again (8x) and so on. This simple law applies with the opposite result to decrease in exposure. It is also important to set the meter to the chosen ISO rating (measure of film or image sensor sensitivity to light).

Average exposure

If the lighting is even most films and image sensors are able to record a full range of tones. Where the tones are evenly distributed the most appropriate exposure is often the average indicated by the light meter. When light or dark tones dominate, however, underexposure or overexposure may occur as the average exposure is no longer appropriate. It is essential to understand how the light meter reads light to have full control over exposure.

Itti Karuson

ACTIVITY 5

Using a diffuse light source (cloudy sky) take individual reflected light meter readings of three pieces of card, one white, one black and one mid-grey. Adjust the card to avoid specular reflections (the card should not appear shiny). The black card should give a reading different by four stops to the reading off the white card . The mid-grey card should be between the two. If the mid-grey card is two stops apart from each, you have a mid-tone the meter sees as the average tone (18% grey).

Make an exposure of each of the three cards using the reflected MIE of each card.

Photograph the white and black cards again using the MIE of the grey card.

Label the results with the MIE, the actual exposure and the tone of the card.

TTL light meters

TTL or 'through the lens' light meters, built into cameras, measure the level of reflected light prior to exposure. They measure only the reflected light from the subject matter within the framed image. The meter averages or mixes the differing amounts of reflected light within the framed image, and indicates an average level of reflected light. The light meter readings are translated by the camera's CPU and used to set aperture and/or shutter speed.

Centre-weighted and matrix metering

Centre-weighted and selective metering systems (matrix metering), common in many cameras, bias the information collected from the framed area in a variety of ways. Centre-weighted metering takes a greater percentage of the information from the central area of the viewfinder. The reading, no matter how sophisticated, is still an average - indicating one exposure value only. Any single tone recorded by the photographer using a TTL reading will reproduce as a mid-tone, no matter how dark or light the tone or level of illumination. This tone is the midpoint between black and white. If the photographer takes a photograph of a black or white wall and uses the indicated meter reading to set the exposure, the final image produced would show the wall as having a mid-tone.

Centre-weighted TTL metering

Automatic TTL exposure modes

If the camera is set to fully automatic or programme mode both the shutter speed and aperture will be set automatically, ensuring an average exposure in response to the level of light recorded by the meter. In low light the photographer using the programme mode should be aware of the shutter speed being used to achieve this exposure. As the lens aperture reaches its widest setting the programme mode will start to use shutter speeds slower than those usually recommended to avoid camera shake. Many cameras alert the photographer to this using an audible or visual signal. This should not be treated as a signal to stop taking photographs but to take precautions to avoid camera shake, such as bracing the camera or by using a tripod.

Semiautomatic

The disadvantage of a fully automatic or programme mode is it can often take away the creative input the photographer can make to many of the shots. A camera set to fully automatic is programmed to make decisions not necessarily correct for every situation.

If your camera is selecting both the aperture and shutter speed you will need to spend some time finding out how the camera can be switched to semiautomatic and manual operation.

Semiautomatic exposure control, whether aperture priority (Av) or shutter priority (Tv), allows creative input from the photographer (**depth of field** and **movement blur**) but still ensures MIE is obtained automatically.

Aperture priority (Av)

This is a semiautomatic function where the photographer chooses the aperture and the camera selects the shutter speed to achieve MIE. This is the most common semiautomatic function used by professional photographers as the depth of field is usually the primary consideration. The photographer using aperture priority needs to be aware of slow shutter speeds being selected by the automatic function of the camera when selecting small apertures in low-light conditions. To avoid camera shake and unintended blur the aperture has to be opened and the depth of field sacrificed.

Kata Bayer

Shutter priority (Tv)

This is a semiautomatic function where the photographer chooses the shutter speed and the camera selects the aperture to achieve correct exposure. In choosing a fast shutter speed the photographer needs to be aware of underexposure as light levels decrease. The fastest shutter speed possible is often limited by the maximum aperture of the lens. In choosing a slow shutter speed the photographer needs to be aware of overexposure when photographing brightly illuminated subject matter. Movement blur may not be possible when using fast film or image sensors set to a high ISO in bright conditions.

Interpreting the meter reading

The information given by the light meter after taking a reading is referred to as the '**meter indicated exposure**' **(MIE).** This is a guide to exposure only. The light meter should not be perceived as having any intelligence or creative sensibilities. The light meter cannot distinguish between tones or subjects of interest or disinterest to the photographer. It is up to the photographer to decide on the most appropriate exposure to achieve the result required. A photographer with a different idea and outcome may choose to vary the exposure. It is the photographer's ability to interpret and vary the meter indicated exposure to suit the mood and communication of the image that separates their creative abilities from others.

If light or dark tones dominate, the indicated exposure will be greatly influenced by these dominant tones. Using the MIE will expose these dominant dark or light tones as mid-tones. Minority light and mid-tones will be overexposed or underexposed. If you consider interest and visual impact within a photograph are created by the use of lighting and subject contrast (amongst many other things), the chances of all the elements within the frame being mid-tones are remote. The information, mood and communication of the final image can be altered through adjusting exposure from MIE.

Average tones

A subject of average reflectance (mid-tone) is placed with equal dark and light tones. All three tones are lit equally by the same diffuse light source.

A reflected reading of the mid-tones will give correct exposure. An exposure using the reflected reading of the dark tone will render it grey and overexpose the mid and light tones. An exposure using the reflected reading of the light tone will render it grey and underexpose the mid and dark tones.

An incident reading will give 'correct' exposure regardless of which tone it is held in front of because it measures the light falling on the subject, not the light reflected from it. The intensity of the light source is constant but the reflected light from the three tones varies.

ACTIVITY 6

In a constant light source take a reflected light reading, 30cm from the subject, of a light or dark tone.

Note the exposure reading.

Now take an incident reading from the subject with the invercone pointing back towards the camera or a reflected reading 30cm from a grey card positioned next to the subject.

Note the exposure readings.

Expose a subject with dominant mid-tones in both bright and dull illumination using the MIE.

Keep a record of both exposures and label the results.

Discuss the similarities and differences of each image.

Dominant dark tones

A subject of average reflectance (mid-tone) is photographed with dominant dark tones. All three tones are lit equally by the same diffuse light source. A reflected light meter reading is taken from the camera. The dominant dark tones reflect less light than 18% grey so the meter indicates an increased exposure compared to a meter reading taken from a mid-tone. The MIE, if used, will result in the dark tones becoming mid-tones and the mid-tones overexposing. If the tones are to be recorded accurately the exposure must be reduced (less time or less light) from that indicated. The amount of reduction is dictated by the level of dominance of the dark tones.

An incident reading will give 'correct' exposure regardless of which tone it is held in front of because it measures the light falling on the subject, not the light reflected from it. The intensity of the light source is constant but the reflected light from the tones varies.

Dominant dark tones
- Itti Karuson

Dominant light tones
- Kata Bayer

Dominant light tones

A subject of average reflectance (mid-tone) is photographed with dominant light tones. All the tones are lit equally by the same diffuse light source. A reflected light meter reading is taken from the camera. The dominant light tones reflect more light than 18% grey so the meter indicates a decreased exposure compared to a meter reading taken from a mid-tone. The MIE, if used, will result in the light tones becoming mid-tones and the mid-tones underexposing. If the tones are to be recorded accurately the exposure must be increased (more time or more light) from that indicated. The amount of increase is dictated by the level of dominance of the light tones.

An incident reading will give 'correct' exposure regardless of which tone it is held in front of because it measures the light falling on the subject, not the light reflected from it. The intensity of the light source is constant but the reflected light from the tones varies.

ACTIVITY 7

Photograph a subject requiring adjusted exposure from that indicated by the light meter. State how the dominant tones would have affected the light meter reading and how the image would have looked if you had not adjusted the exposure.

Digital exposure

The colour information in a 24-bit RGB digital image file is separated into three 'channels' (8 bits per channel). Each colour channel is capable of storing 256 levels of brightness between black (level 0) and white (level 255). When viewing all three colour channels simultaneously each pixel is able to be rendered in any one of 16.7 million colours (256 x 256 x 256).

These brightness levels can often be displayed as a simple graph or histogram in both the capture device and the image editing software. The horizontal axis displays the brightness values from left (darkest) to right (lightest). The vertical axis of the graph shows how much of the image is found at any particular brightness level. If the subject contrast or 'brightness range' exceeds the latitude of the capture device or the exposure is either too high or too low then tonality will be 'clipped' (shadow or highlight detail will be lost).

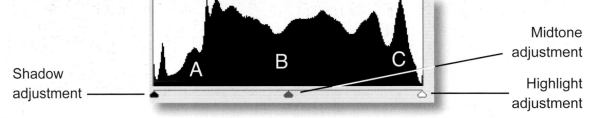

Shadow adjustment

Midtone adjustment

Highlight adjustment

Histograms

During the capture stage it is usually possible to check how the device has handled or interpreted the tonality and colour of the subject. This useful information can often able be displayed as a 'histogram' on the LCD screen of high quality digital cameras immediately after capture, or in the scanning software during the scanning process. The histogram displayed shows the brightness range of the subject in relation to the latitude or 'dynamic range' of your capture device's image sensor. Most digital camera sensors have a dynamic range similar to colour transparency film (around five stops).

Note > You should attempt to modify the brightness, contrast and colour balance at the capture stage to obtain the best possible histogram before editing begins in the software.

Optimising tonality

In a good histogram, one where a broad tonal range with full detail in the shadows and highlights is present, the information will extend all the way from the left to the right side of the histogram. The histogram below indicates missing information in the highlights (on the right) and a small amount of 'clipping' or loss of information in the shadows (on the left).

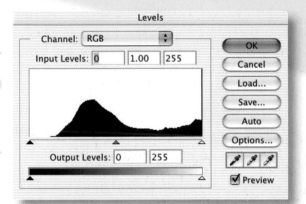
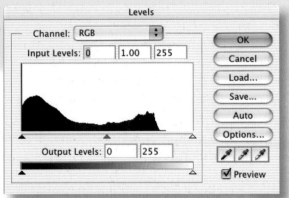

Histograms indicating image is either too light or too dark

Brightness

If the digital file is too light a tall peak will be seen to rise on the right side (level 255) of the histogram. If the digital file is too dark a tall peak will be seen to rise on the left side (level 0) of the histogram.

Solution: Decrease or increase the exposure/brightness in the capture device.

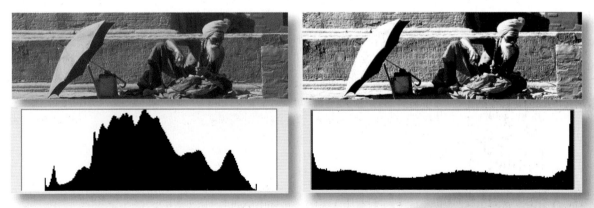

Histograms indicating image either has too much contrast or not enough

Contrast

If the contrast is too low the histogram will not extend to meet the sliders at either end.
If the contrast is too high a tall peak will be evident at both extremes of the histogram.

Solution: Increase or decrease the contrast of the light source used to light the subject or the contrast setting of the capture device. Using diffused lighting rather than direct sunlight or using fill-flash and/or reflectors will ensure that you start with an image with full detail.

Optimising a histogram after capture

The final histogram should show that pixels have been allocated to most, if not all, of the 256 levels. If the histogram indicates large gaps between the ends of the histogram and the sliders (indicating either a low-contrast scan or low-contrast subject photographed in flat lighting) the subject or original image should usually be re-captured a second time.

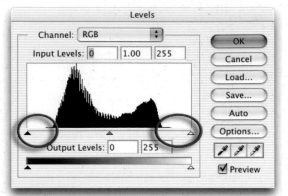 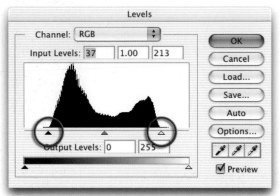

Small gaps at either end of the histogram can, however, be corrected by dragging the sliders to the start of the tonal information. Holding down the Alt/Option key when dragging these sliders will indicate what, if any, information is being clipped. Note how the sliders have been moved beyond the short thin horizontal line at either end of the histogram. These low levels of pixel data are often not representative of the broader areas of shadows and highlights within the image and can usually be clipped (moved to 0 or 255).

Moving the 'Gamma' slider can modify the brightness of the mid-tones. If you select a Red, Green or Blue channel (from the channel's pull-down menu) prior to moving the Gamma slider you can remove a colour cast present in the image. For those unfamiliar with colour correction the adjustment feature 'Variations' (Image > Adjustments > Variations) in Photoshop gives a quick and easy solution to the problem. After correcting the tonal range using the sliders click 'OK' in the top right-hand corner of the Levels dialog box.

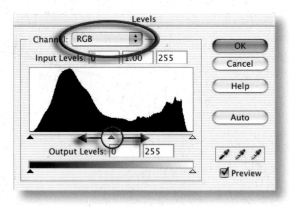

Note > Variations is not available for Photoshop users working in 16 Bits/Channel mode.

Colour

Neutral tones in the image should appear desaturated on the monitor. If a colour cast is present try to remove it at the time of capture or scanning if possible.

Solution: Control colour casts by using either the white balance on the camera (digital) or by using an 80A or 80B colour conversion filter when using tungsten light with daylight film. Use the available colour controls on the scanning device to correct the colour cast and/or saturation.

Jacqui Melville

Itti Karuson

Paul Allister

contrast and compensation

Shivani Tyagi

essential skills

~ Gain knowledge and understanding about contrast and exposure
 compensation and their relationship to the correct exposure.
~ Understand the relationship between lighting contrast, lighting ratios,
 subject contrast and subject brightness range.
~ Create images demonstrating an understanding of contrast and exposure
 compensation.
~ Document the progress and development of these skills.

Contrast

The human eye simultaneously registers a wide range of light intensity. Due to their limited latitude film and image sensors are unable to do this. The difference in the level of light falling on or being reflected by a subject is called contrast. Without contrast photographic images can appear dull and flat. It is contrast within the image that gives dimension, shape and form. Awareness and the ability to understand and control contrast is essential to work successfully in the varied and complex situations arising in photography. Contrast can be subdivided into three areas:

~ Subject contrast
~ Lighting contrast
~ Brightness range.

Subject contrast

Different surfaces reflect different amounts of light. A white shirt reflects more light than black jeans. The greater the difference in the amount of light reflected the greater the subject contrast or 'reflectance range'. The reflectance range can only be measured when the subject is evenly lit. The difference between the lightest and darkest tones can be measured in stops. If the difference between the white shirt and the black jeans is three stops then eight times more light is being reflected by the shirt than by the jeans (a reflectance range of 8:1).

One stop = 2:1, two stops = 4:1, three stops = 8:1, four stops = 16:1

Paul Allister

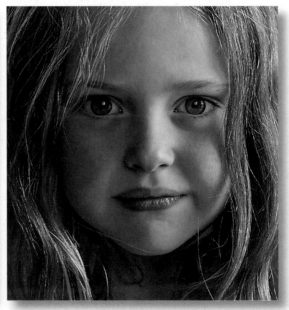

Mark Galer

A 'high-contrast' image is where the ratio between the lightest and darkest elements is 32:1 or greater.

A 'low-contrast' image is where the ratio between the lightest and darkest elements is less than 8:1.

Lighting contrast

When harsh directional light strikes a subject the overall contrast increases. The highlights continue to reflect high percentages of the increased level of illumination whilst the shadows reflect little extra.

Overall image contrast therefore is determined by the combined effects of subject contrast or reflectance range and the 'lighting contrast'

Lighting contrast describes the difference in the level of illumination between the main directional light (key light) and any light falling on the shadows (fill-light). The difference can be measured in stops and recorded as a 'lighting ratio'. If the difference between the light illuminating the highlights and the light illuminating the shadows is two stops, the lighting ratio is given as 4:1, i.e. four times more light strikes the tones facing the light as the same tones in the shadows. This is easily measured by taking an incident light meter reading in the light and then in the shadows.

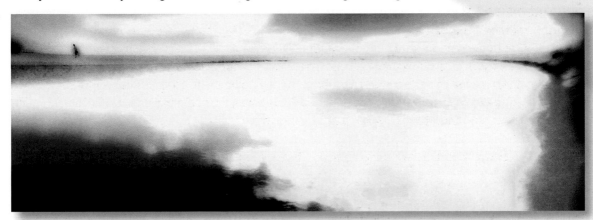

Itti Karuson

On location - when there is cloud covering the sun the light is diffused or softened. The difference between a tone placed in the diffused light and open shade (away from structures and large objects) may be less than one stop, giving a lighting ratio of less than 2:1. The lighting may be described as being flat and the lighting contrast as low.

When direct sunlight strikes the subject the difference between a tone placed in the sun and the same tone placed in covered shade may increase beyond two stops or 4:1. This directional light creating highlights and shadows is described as high contrast.

In the studio - lighting contrast is controlled by the photographer. The direction, intensity, degree of diffusion and amount of fill-light will all be deciding factors in creating a lighting ratio suitable for the desired lighting contrast range.

Stops difference	Light ratio	Stops difference	Light ratio
⅔	1.6:1	2	4:1
1	2:1	2 ⅓	5:1
1 ⅓	2.5:1	2 ⅔	6:1
1 ⅔	3:1	3	8:1

Brightness range

Subject luminance range is the combined effects of subject and lighting contrast. Because the acronym 'SLR' is more usually associated with the term single-lens reflex, subject luminance range is often referred to as subject brightness range.

If a subject with a reflectance range of 32:1 (high subject contrast) is placed in harsh directional sunlight with a lighting ratio of 4:1, the overall contrast or 'subject brightness range' (SBR) of this scene can be recorded as 128:1.

Subject brightness range (SBR) = Reflectance range x Lighting ratio.

Image capture mediums have a limited tonal or brightness range. A subject photographed in high-contrast lighting may exceed this recordable range. The ability of the film or image sensor to accommodate a brightness range is referred to as its 'latitude'.

Colour transparency film, image sensors caturing in the JPEG or TIFF file formats and colour prints have the ability to accommodate a brightness range of only 32:1 or five stops. Black and white prints will accommodate a brightness range of 128:1 or seven stops. With this knowledge the photographer will understand any highlight or shadow more than two stops brighter or darker than the mid-tone may not register with any detail using certain media. When working in black and white or RAW the photographer has the increased flexibility to extend this range three stops either side of the mid-tone and still register detail. Specialist processing and printing techniques can extend this range still further.

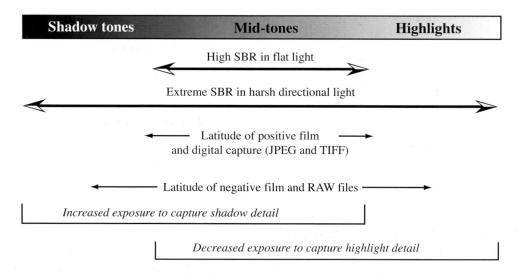

A subject with a high or extreme brightness range can exceed the latitude of the sensor or film

Awareness of the subject brightness range and the capability of the photographic medium allows the photographer to previsualise or predict the outcome of the final image. When the brightness range exceeds the film or image sensor's capabilities the photographer has the option to lower the lighting contrast or adjust the exposure to protect shadow or highlight detail that would otherwise not record. This is called 'exposure compensation'.

Exposure compensation

When working on location the lighting (sunlight) already exists. There is often little the photographer can do to lower the brightness range. In these instances exposure compensation is often necessary to protect either shadow or highlight detail. The results of exposure compensation are more easily assessed using transparency film or digital capture. The amount of compensation necessary will vary depending on the level of contrast present and what the photographer is trying to achieve. Compensation is usually made in 1/3 or 1/2 stop increments but when a subject is back lit and TTL metering is used the exposure may need increasing by two or more stops depending on the lighting contrast. Remember:

Increasing exposure will reveal more detail in the shadows and dark tones
Decreasing exposure will reveal more detail in the highlights and bright tones

Exposure compensation adjustment

The compensation dial or adjusted menu selection is required when the photographer wishes to continue working with an automatic metering system instead of manual controls. Using an automatic metering mode the photographer cannot simply adjust the exposure, from that indicated by the meter, using the aperture or shutter speed. The automatic mode will simply re-compensate for the adjustment.

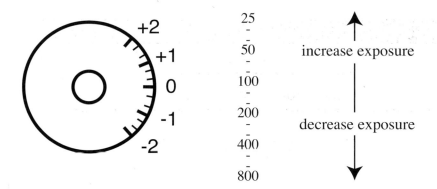

Compensating by altering film speed

If the camera is not equipped with exposure compensation facilities compensation may be achieved by altering the speed of the film or image sensor. By decreasing the speed from 100 ISO to 50 ISO the photographer will increase the exposure by one stop. By doubling the speed the exposure will be decreased by one stop. Film is available in 1/3 stop increments so this allows compensation in 1/3 increments. The disadvantage of the film speed dial is that it is usually not conveniently situated on the camera, may require an additional button to be depressed before it can be altered, and there is usually no indication in the viewfinder that compensation is being used. Without this reminder the photographer must return the ISO to the correct setting or run the risk of compensating all subsequent shots. Most digital cameras display this information in the viewfinder.

Assessing the degree of compensation

Photographers calculate the degree of compensation from MIE in a variety of different ways. The method chosen is often dictated by whether speed or accuracy is required.

Digital histogram - Some digital cameras allow the user to view a 'histogram' of the exposure immediately after capture and/or indication of highlight clipping (overexposure).

Bracketing - The photographer can estimate the necessary compensation by bracketing the exposures. To bracket the exposure the photographer must expose several frames, varying the exposure in 1/3 or 1/2 stop increments either side of the MIE.

18% Grey card - Photographers can use a mid-tone of known value from which to take a reflected light meter reading. A mid-tone of 18% reflectance is known as a 'grey card'. The grey card must be at the same distance from the light source as the subject. Care must be taken to ensure the shadow of neither the photographer nor the light meter is cast on the grey card when taking the reading. When using colour transparency film or digital image sensor the indicated exposure is suitable for an SBR not exceeding 32:1. If highlight or shadow detail is required the exposure must be adjusted accordingly. When using black and white or colour negative film the indicated exposure is suitable for an SBR not exceeding 128:1. If the SBR exceeds 128:1 the exposure can be increased and the subsequent development time decreased. See 'The Zone System'.

Polaroid - Working with some medium-format cameras, a photographer has the added advantage of being able to use Polaroid to assess exposure and composition. Most film has a Polaroid of equal ISO and comparative contrast range. To best understand the relationship between Polaroid and film, testing of both is recommended. This will give you the best correlation between how the correct exposure for film would appear on an equivalent Polaroid. Polaroid film holders (backs) fit most medium- and all large-format cameras. Polaroid backs suitable for small-format cameras are limited.

Caucasian skin - A commonly used mid-tone is Caucasian skin. A reflected reading of Caucasian skin placed in the main light source (key light) is approximately one stop lighter than a mid-tone of 18% reflectance. Using this knowledge a photographer can take a reflected reading from their hand and increase the exposure by one stop to give an exposure equivalent to a reflected reading from an 18% grey card. Adjustments would be necessary for an SBR exceeding the latitude of the film or image sensor.

Re-framing - If the photographer is working quickly to record an unfolding event or activity the photographer may have little or no time to bracket or take an average mid-tone reading. In these circumstances the photographer may take a reading quickly from a scene of average reflectance close to the intended subject. This technique of re-framing may also include moving closer to the primary subject matter in order to remove the light source and the dominant light or dark tones from the framed area. Many modern cameras feature an exposure lock to enable the photographer to find a suitable exposure from the environment and lock off the metering system from new information as the camera is repositioned.

Judgement - The fastest technique for exposure compensation is that of judgement, gained from experience and knowledge. The photographer must previsualise the final image and estimate the degree of compensation required to produce the desired effect.

Compensation for back lighting

The most common instance requiring exposure compensation is 'back lighting' using a TTL meter. The metering system will be overly influenced by the light source and indicate a reduced exposure. As the light source occupies more and more of the central portion of the viewfinder so the indicated exposure is further reduced. The required exposure for the subject may be many times greater than the indicated exposure.

Mark Galer

If the camera is in manual mode or equipped with an exposure lock, the photographer can meter for the specific tonal range required and then re-frame the shot. An alternative used by many professionals is to adjust the exposure using the exposure compensation facility. Using this technique can avoid re-framing after first metering.

ACTIVITY 1

Choose four different lighting situations where the subject is back-lit.

Using digital capture or medium-speed transparency film take a photograph of each subject with the 'meter indicated exposure' or MIE.

Do not reposition the frame. Make a record of the exposures.

Using your own judgement compensate the exposure using either the exposure compensation facility or adjusting ISO. Make a record of the exposures.

Take a meter reading for the shadow area and with the camera set to manual make one exposure at this reading. Make a record of the exposure.

Take a meter reading for the highlight area and with the camera set to manual make one exposure at this reading. Make a record of the exposure.

Process the images and label the results of each frame.

Discuss your results with other students.

Summary of exposure compensation

Hand-held light meters

A hand-held reflected light meter reading measures the level of light reflected from the subject. The resulting exposure is an average between the light and dark tones present. When light and dark tones are of equal distribution this average reading is suitable for exposure. When light or dark tones dominate the photographer must either take a reflected meter reading of a known mid-tone and compensate accordingly, or take an incident reading of the light falling on the subject.

TTL meters

The 'through-the-lens' (TTL) light meter measures the level of reflected light from the subject. The TTL meter does not measure the level of illumination (ambient light). The resulting exposure is an average between the light and dark tones present. When light and dark tones are of equal distribution within the frame this average light reading is suitable for exposing the subject. When light or dark tones dominate the photographer must either meter a known mid-tone or compensate the exposure accordingly.

Summary of exposure compensation

| Dominant light tones | increase exposure | + | Open up |
| Dominant dark tones | decrease exposure | – | Stop down |

Extreme contrast

Colour film/image sensor

| Increase highlight detail | decrease exposure | – | Stop down |
| Increase shadow detail | increase exposure | + | Open up |

Black and white negative
SBR exceeding 128:1 increase exposure/reduce development time

ACTIVITY 2

Place a small subject of dominant mid-tones one metre from a bright white background.
Light with a diffuse light source (floodlight) and take a reflected light reading from the camera position.
Next take a reflected light reading of the subject only.
Test your judgement by determining correct exposure and exposing one frame only.

Stuart Wilson

Samantha Everton

sensitivity and image capture

Kata Bayer

essential skills

~ Gain a knowledge and understanding of the various light-sensitive mediums
 available to the photographer.
~ Understand the use of these materials and devices, their advantages,
 limitations and processing.
~ Create images using technique, observation and selection demonstrating a
 practical understanding of light-sensitive mediums.
~ Document the progress and development of these skills.

Introduction

There is an overwhelming range of image capture mediums now available to the professional and amateur photographer. These range from digital image sensors to various colour and black and white film emulsions. Choosing the appropriate medium for the job is an essential skill for every photographer.

Capture mediums

Light-sensitive surfaces can be divided into four main types:

~ Digital image sensors
~ Black and white negative
~ Colour negative
~ Colour transparency (positive or slide film).

Digital image sensors are not interchangeable but some digital cameras allow alteration of the image sensor to its degree of sensitivity to light (ISO setting) and 'white balance' adjustments to allow for different light sources used in the illumination of the subject.

Colour negative and colour transparency films are easily and quickly distinguished in the shops by a number of identifying labels. Films ending with the suffix 'chrome', e.g. Ektachrome, Fujichrome, are transparency films. Film names ending with the suffix 'color' are negative films, e.g. Fujicolor, Kodacolor.

Film boxes will indicate the type of processing required for the film. C-41 indicates the film is a colour negative film whilst E-6 indicates the film is a transparency reversal film. E-6 processing is usually not carried out by high street mini-labs.

Relative size of formats *Relative shape of formats*

Each main film type (negative or positive) is available in the following formats:

~ 35mm
~ 120 roll film
~ 4" x 5" sheet film.

120 roll film is suitable for the entire range of medium-format cameras from the smaller 6 x 4.5cm cameras to the popular 6 x 6cm and 6 x 7cm cameras through to the specialist panoramic cameras shooting frames as wide as 6 x 17cm.

Choosing a capture medium

There has been a shift towards digital image capture in recent years as it has the advantage of producing an image almost immediately (no processing required). It creates image files, downloaded to a computer, suitable for desktop publishing. A limiting factor has been the expense of digital cameras capable of providing the quality suitable for large commercial illustration (see *Essential Skills: Digital Imaging*).

Commercial photography reproduced in magazines has traditionally been produced using positive or reversal (transparency) film. The advantage of reversal over negative film has been that it is a one-step process to achieve a positive image.

A negative film emulsion will give you, within its limitations, an image opposite to that seen through the viewfinder. It is only when a negative is printed that it becomes a positive image. The advantage of negative film is its greater 'latitude' and ability to handle higher subject contrast levels than positive film.

Image processing

Digital image processing is carried out on a computer platform. The commercial illustration industry favours Apple Macintosh computers and the software 'Adobe Photoshop'.

Colour transparency film is processed using the E-6 process. This is a Kodak processing system and will process nearly all colour positive films. Colour negative film is processed using the C-41 process. This is also a Kodak processing system and will process nearly all colour negative films.

Colour film processing should be undertaken by a professional laboratory. Although it is possible to purchase chemicals to process colour film the money saved may well be a false economy when considering the experience and equipment required to produce consistent and accurate colour processing.

The number of black and white processing systems are as varied as the number of films available. Although not covered in this book it is recommended all photographers develop a thorough understanding of black and white processing. It is relatively simple technology (it has changed little since its introduction) and easy to learn.

Appropriate exposure

Assessing correct image exposure can be achieved by viewing the film on a light box or by examining a histogram of the digital image file. It takes practice to be precise about the subtleties of underexposure and overexposure but there is a simple starting point. If there is no image detail something is wrong.

If, when viewing a digital image, a large peak is apparent at one or both ends of the histogram then detail may be missing through excessive contrast or poor exposure.

If negative film appears 'dense' (transmits very little light) with no visible detail it is probably overexposed. If positive film appears 'dense' it is probably underexposed.

If negative film appears 'thin' (transmits nearly all light) with no visible detail it is probably underexposed. If positive film appears 'thin' it is probably overexposed.

59

Positive image capture

Positive image capture can be further subdivided:

~ Digital capture
~ Professional or general purpose transparency film
~ Tungsten or daylight transparency film.

Digital capture

Digital capture has already impacted upon commercial photography. For many commercial photographers who have not yet started to capture digitally it is not a question of 'if', but 'when'. At the present time the hardware and software required for high resolution digital image capture are the more expensive option compared to the equivalent film capture, but for those photographers who require lower resolution images digital is the answer.

Professional film

Professional film is made to the highest quality-control procedures. The film material is more consistent between batches than the equivalent general purpose film and is essential when speed or colour variations cannot be tolerated. Professional film should only be purchased if it has been stored in a refrigerator. The increased price for professional film is not warranted on many jobs that the photographer undertakes.

Tungsten and daylight

Tungsten film is only available as professional film and is distinguished by the letter 'T' after the ISO rating. It is available in three ISO ratings and is generally used for commercial studio applications. Many photographers refer to the film by its prefix letters, e.g. EPY, EPT and EPJ are current examples.

Most transparency film is balanced for daylight (5500K). Colour film can only achieve correct colour balance when it is used with the appropriate light source. It is possible, however, to achieve interesting results by using a film with an incorrect light source. If a daylight film is used with tungsten light a very warm sepia effect is obtained. If tungsten film is used with a daylight source a cold blue effect will be the result. In both cases the ISO will change, resulting in variations to exposure.

Tungsten		
ISO	**FORMAT**	**PROCESS**
64	small, medium, large	E-6
160	small, medium	E-6
320	small	E-6
Daylight		
ISO	**FORMAT**	**PROCESS**
64 & 100	small, medium, large	E-6
200	small	E-6
400	small, medium	E-6

www.kodak.com

Image characteristics

Capture mediums share the following characteristics:

~ Sensitivity (speed)
~ Sharpness (grain and/or resolution)
~ Contrast.

Sensitivity

All films and image sensors are assigned an ISO (International Standards Organisation) rating. This rating indicates its sensitivity to light. The higher the rating the greater the sensitivity. Most image sensors can be assigned different ratings as and when required.

Films are available from 25 ISO to 3200 ISO whilst image sensors are available that can be rated between 100 and 800 ISO. Each time the ISO doubles the film or image sensor is twice as light sensitive, e.g. a 400 ISO film requires only half the exposure of a 200 film. The 400 film can therefore be said to be one stop faster than a 200 ISO film and two stops faster than a 100 ISO film. Films are often referred to as slow, medium or fast. A film is described as being slow if its ISO is 64 or less and fast if its ISO is 400 or more.

The advantage of using fast film or an image sensor rated at a high ISO is a photographer is able to use faster shutter speeds to either freeze action or avoid camera shake. The disadvantage of using faster film or an image sensor rated at a high ISO is its decreased resolution or sharpness (film only) and the increased size of film grain or digital 'noise'.

Sharpness

A digital image is made up of 'pixels' or picture elements whilst the silver image on film is made up from a grain pattern (a range of dots). As a film's ISO increases the size of the grain increases whilst increased noise levels result from raising the ISO of an image sensor. The grain pattern or noise becomes apparent when the image is enlarged.

As the image is enlarged it appears progressively less sharp. An image created using slow speed film or a high resolution image sensor will enlarge to a greater physical size before the sharpness becomes unacceptable than if the same image was created using a fast speed film or lower resolution image sensor. Reduced grain size or low noise levels are strong selling points for fast films and high ISO image sensors.

Contrast

Digital image sensors have a 'latitude' similar to transparency film and so great care must be taken to protect images from loss of detail resulting from excessive contrast.

As the ISO rating of film increases the contrast decreases. The slower the film, the higher the contrast. As film is 'pushed', however (increasing the recommended film speed and processing time), the contrast increases. This is a result of the processing and not the film speed used for exposure. High-contrast film is not easy to use with high-contrast subject matter. If the photographer is not skilled with this combination, highlight and shadow information may be lost.

Limitations of film capture

Expiry date

At the time of manufacture all film products have an expiry date printed on their packaging. Do not use film once this date expires. The manufacturer will not guarantee correct rendition of colour and reliable results cannot be predicted. Store unexposed film at a constant temperature, preferably in a refrigerator, but do not freeze.

Colour temperature and white balance

It is not important to fully understand the theory of colour temperature other than to know that capturing colour images requires the correct match between capture medium and light source to avoid excessive colour casts. Black and white film is relatively unaffected by colour temperature, although a small increase in exposure (as indicated by the MIE reading) is often required when using tungsten lights.

> **Tungsten film is rated at 3200K and used with tungsten lighting.**
> **Daylight film is rated at 5500K and used with flash and daylight.**

To render correct colour, the use of a 'white balance' or filtration can be used to balance any image sensor or film to any lighting situation. The filtration required for film is listed in the manufacturer's specifications packaged with the film.

Reciprocity

Reciprocity, more correctly referred to as reciprocity failure, is a measure of the film's ability or inability to handle extreme exposure times. Reciprocity, in general terms, takes effect when shutter speeds are greater than 1 second when using daylight colour film, greater than 30 seconds when using tungsten colour film and 1 second when using black and white. All manufacturers issue a technical information sheet with their professional film packaging stating the reciprocity values relevant to that batch (manufacturing identification) of film. This should be followed closely.

Without going into the causes of reciprocity the remedy is to reduce shutter speed (time) and compensate by increasing aperture (intensity). Increasing exposure by increasing time will only compound the problem.

The results of not compensating for reciprocity is an underexposed image, varying shifts in colour rendition and unpredictable results.

ACTIVITY 1

Photograph a subject of average contrast using the capture medium of your choosing.

Adjust shutter speed and the intensity of light so exposure times start at 1 second with the aperture at f2.8 or f4.

In one stop increments increase exposure time to 64 seconds.

Label the results for reference, comparison and discussion.

At what exposure time did the images suffer reciprocity failure or excessive levels of noise?

Latitude

Latitude is a measure of the ability or inability to record detail in subjects with extreme contrast and variation from correct exposure.

It is an accepted rule that most modern film emulsions and digital image sensors have an approximate five to seven stops latitude, although this is sure to increase as manufacturers develop new technology. This means that if you underexposed an 18% grey card by three stops it would appear black on the processed transparency film or digital file. If you overexposed it by three stops it would appear white.

The human eye has almost limitless latitude because of its ability to compensate for changes in contrast and light levels. Film and image sensors are incapable of doing this due to their limited latitude. Black and white and colour negative film have a latitude of seven stops and can handle a contrast ratio of 128:1. Colour transparency and most image sensors with five stops latitude can handle a contrast ratio of 32:1. The human eye is capable of adjusting to a ratio in excess of 1000:1.

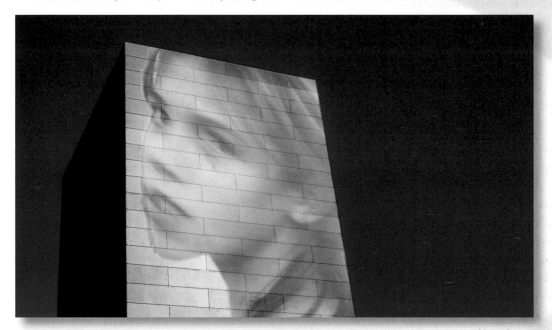

Kata Bayer

ACTIVITY 2

Choose a capture medium (digital, transparency or negative film).

Light a grey card with a diffuse light source; ensure the card fills the frame.

De-focus the camera and take a reflected or incident meter reading.

Either side of correct exposure, overexpose and underexpose in sequence one to five stops.

Process the film or download the digital files and open in Adobe Photoshop.

Evaluate and document the point at which the film or image sensor is unable to record detail above and below correct exposure (latitude).

This indicates the capture medium's latitude and its ability to handle incorrect exposure.

Limitations of digital capture

Most digital image sensors capture images using 12 bits of memory dedicated to each of the three colour channels (recording up to 4096 individual brightness levels). When the camera saves this data using the TIFF or JPEG file formats this extensive colour information is condensed to 8 bits per channel (256 levels per channel). If the exposure and white balance are accurate, and limited image editing is required, the 8 bits of data per channel are usually sufficient to produce a high quality digital image for monitor display or print production. If extensive colour and tonal manipulation is required, however, the information is usually insufficient to render a high quality image where tonal and colour transitions are smooth, continuous and exhibit no signs of tonal banding or posterization. If, however, the 'camera RAW' file format is selected in the camera preferences (an option on most 'prosumer' cameras, digital SLRs and professional backs) the unprocessed image data can be imported into software capable of managing the translation of the RAW data into a high quality 16 Bit/Channel file with an optimised histogram.

To access RAW quality the user requires a camera capable of saving the RAW data and software capable of editing it.

Processing camera RAW

Adobe released a camera RAW plug-in for Photoshop 7 in 2003 and this plug-in became a standard feature with the release of Photoshop CS. The RAW file is opened into a camera RAW dialog box where the user can, amongst other things, set the white balance, optimise the histogram, apply image sharpening and select the colour profile and bit depth before opening the file into the Photoshop interface. If the user selects the 16 Bits/Channel option, the 12 bits per channel data from the image sensor is rounded up - each channel is now capable of supporting 32,769 levels.

Digital negative

The secondary advantage of adopting a 'shoot now – process later' workflow is the deferred white balance, Unsharp Mask and file option settings that can all be handled after the initial capture. When settings are finally allocated to the raw data before opening in Photoshop as an enhanced file the original camera RAW file is not overwritten or modified in any way. For this reason the camera RAW file is quickly becoming known as the 'digital negative'. The user is able to return to the camera RAW file at any time and enter alternative settings to create a different 'start point' for editing the final image in Photoshop.

Note > The RAW file is a master file from which versions are extracted. The RAW file is not permanently adjusted by altering the settings in the dialog box.

Distribution of data

One would think that with all of this extra data the problem of banding or image posterisation due to insufficient levels of data (a common problem with 8-bit image editing) would be consigned to history. Although this is the case with mid-tones and highlights, shadows can still be subject to this problem. The reason for this is that the distribution of levels assigned to recording the range of tones in the image is far from equitable. The brightest tones of the image (the highlights) use the lion's share of the 4096 levels available whilst the shadows are comparatively starved of information.

Tonal distribution in 12-bit capture

Darkest Shadows	- 4 stops	- 3 stops	- 2 stops	-1 stop	Brightest Highlights
128 Levels	256	512	1024	2048	4096 Levels

distribution of levels

Most digital imaging sensors capture images using 12 bits of memory dedicated to each of the three colour channels, resulting in 4096 tones between black and white. Most of the imaging sensors in digital cameras record a subject brightness range of approximately five to seven stops, (five to seven f-stops between the brightest highlights with detail and the deepest shadow tones with detail).

an example of posterisation or banding

Shadow management

CCD and CMOS chips are, however, linear devices. This linear process means that when the amount of light is halved, the electrical stimulation to each photoreceptor on the sensor is also halved. Each f-stop reduction in light intensity halves the amount of light that falls onto the receptors compared to the previous f-stop. Fewer levels are allocated by this linear process to recording the darker tones. Shadows are 'level starved' in comparison to the highlights that have a wealth of information dedicated to the brighter end of the tonal spectrum. So rather than an equal amount of tonal values distributed evenly across the dynamic range, we actually have the effect as shown above. The deepest shadows rendered within the scene often having fewer than 128 allocated levels, and when these tones are manipulated in post production Photoshop editing there is still the possibility of banding or posterisation.

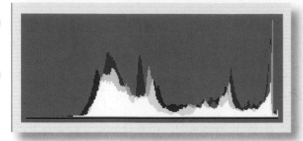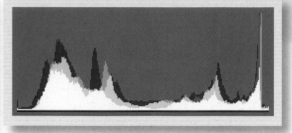

Expose right and adjust left

'Expose right' and multiple exposures

This inequitable distribution of levels has given rise to the idea of 'exposing right'. This work practice encourages the user seeking maximum quality to increase the exposure of the shadows (without clipping the highlights) so that more levels are afforded to the shadow tones. This approach to make the shadows 'information rich' involves increasing the amount of fill light or lighting with less contrast in a studio environment. If the camera RAW file is then opened in the camera RAW dialog box the shadow values can then be reassigned their darker values to expand the contrast before opening it as a 16 Bit/Channel file. When the resulting shadow tones are edited and printed, the risk of visible banding in the shadow tones is greatly reduced.

Separate exposures can be combined in image editing in Adobe Photoshop

This approach is not possible when working with a subject with a fixed subject brightness range, e.g. a landscape, but in these instances there is often the option of bracketing the exposure and merging the highlights of one digital file with the shadows of a second. The example above shows the use of a layer mask used to hide the darker shadows in order to access the bit-rich shadows of the underlying layer and regain the full tonal range of the scene. See *Essential Skills: Photoshop CS* for detailed post production editing techniques.

66

Pushing and pulling film

Photographers may push or pull film to alter the resulting contrast. A photographer may also have to push film on location when the ambient light is low. A safety net all photographers can use when using film is the manipulation of processing after exposure. This applies to all film materials. Despite the precision of the camera and metering systems used, human and equipment error can still occur when taking a photograph.

If the situation allows, bracketing (exposure one and two stops either side of and including normal) is a way of ensuring correct exposure. When there is not the opportunity to bracket exposure and all exposures are meter indicated exposure (MIE) it is advisable to clip test the film.

Clip test

Clip testing is a method of removing the first few frames from an exposed roll of film and processing as normal (i.e. to manufacturer's specifications). If these frames appear underexposed, a push process (over processing the film) may improve or compensate for any error in exposure. If overexposure is evident a pull process (under processing) may correct the result.

The amount of pushing or pulling required to produce an acceptable result is generally quantified in stops. If an image appears underexposed by one stop push the film one stop. If an image appears overexposed one stop pull the film one stop.

Push processing colour transparency having correct exposure is also an option. It has the effect of cleaning up the highlights and giving an appearance of a slight increase in contrast. Pushing in excess of what would be required to achieve this can be an interesting exercise. The results can be unpredictably dramatic. Most professional film processing laboratories offer this service.

Normal process

One stop push
- Fabio Sarraff

ACTIVITY 3

Load a camera with colour transparency.

Deliberately underexpose by one and two stops subjects with average contrast.

Clip test the film - normal process. Clip test again - one stop, two stop and three stop push.

Assess the result and process the rest of the film at processing levels you determine.

Cross processing effect

Similar to over- and under-processing is the practice of processing a film in chemicals different to that suggested by the manufacturer.

If a transparency film normally processed E-6 is instead processed C-41 (colour negative) the result is quite different to what would be expected. The result is a transparency with negative colours and tones.

Matching a film to an incorrect process can be done in any combination but the results can vary from amazing to very disappointing, but well worth the experimentation.

It is important to note film speed changes when cross processing. As a general rule transparency film should be underexposed by one stop when processing in C-41, and negative film overexposed by one stop. This is only a guide and variations in film speed and processing should be tested to obtain the result you want.

Digital cross processing

Using the software Adobe Photoshop it is possible to create a visual equivalent of cross processing using digital editing techniques (see *Essential Skills: Photoshop CS*).

Normal process

Cross process
Michael Wennrich

ACTIVITY 4

Photograph subjects of varying contrast using transparency film or digital capture.

Bracket the exposures and keep a record of aperture and time if using film.

Use Adobe Photoshop to create the effect of cross processing or process the film using the C-41 process (consult the lab prior to processing).

Label the results for reference, comparison and discussion.

Image preview

Polaroid

Since its introduction in 1946 Polaroid materials have become a common tool in the assessment of exposure, contrast, composition and design. To most people, whether it be the photographer, a client, an art director or someone wanting a family portrait it is the first evidence of the photographic process and an indicator of where improvements can be made. Polaroid has become 'the rough drawings' on the way to the final photograph.

All Polaroid materials, colour or black and white, will give a positive image. In some cases a negative, as well as a positive, will be produced that can be printed in the normal way at a later date.

When using Polaroid follow the instructions relating to film speed (ISO or ASA) closely and observe the processing times relating to room temperature. It is important processing times are followed carefully.

When assessing a Polaroid for exposure relative to another film type it should be realised more detail will be seen in a correctly exposed colour transparency than will be seen in the Polaroid's positive reflection print. This is because transparencies are viewed by transmitted light and prints by reflected light. The Polaroid will appear 'thin' if it is overexposed and 'dense' if it is underexposed. Types of Polaroid film suitable for this subject are listed below.

TYPE	ISO	FORMAT
54 (b/w)	100	Large
55 (b/w-negative)	50	Large
59 (colour)	80	Large
64 (colour-tungsten)	64	Large
664 (b/w)	100	Medium
665 (b/w-negative)	80	Medium
690 (colour)	100	Medium

www.polaroid.com

Digital display

Digital capture negates the use of Polaroid film if the captured image can be downloaded to a suitable computer. The computer must have a monitor and software capable of displaying the digital file at high resolution together with a histogram of the image levels.

ACTIVITY 5

Either: establish an appropriate digital platform for previewing digital files.

Or: using a diffuse light source light a person's hand. Correctly expose (incident reading) onto Polaroid.

Expose onto colour film using Polaroid as your means of determining exposure and composition.

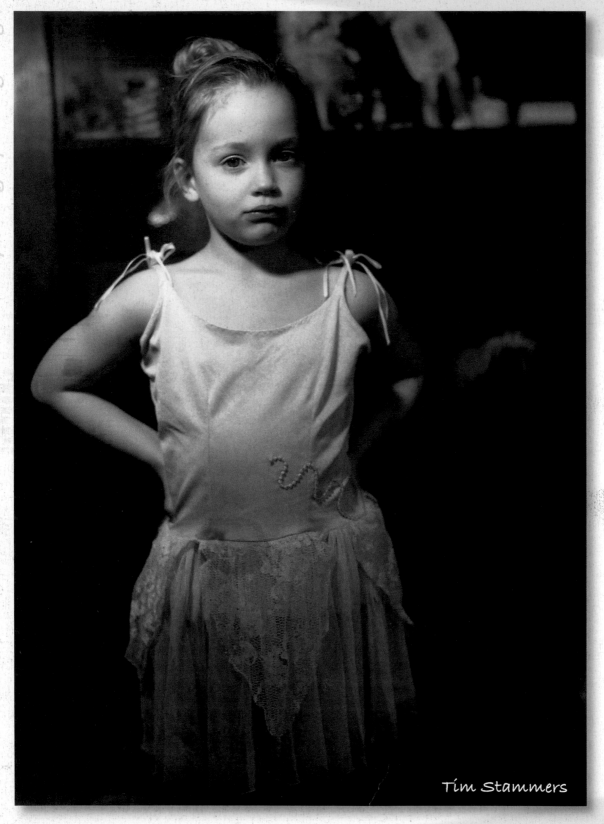

Tim Stammers

filters

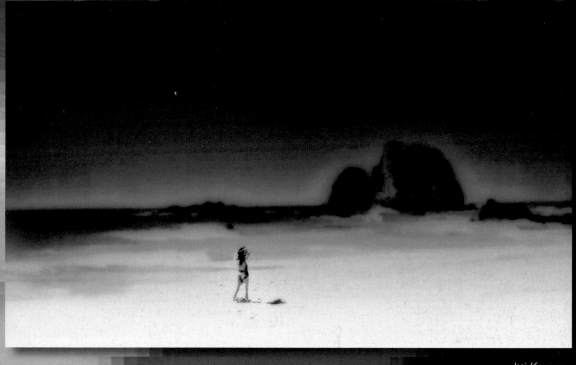

Itti Karuson

essential skills

~ A knowledge and understanding of photographic filters.
~ An understanding of the appropriate application of filters to modify
 light for the purpose of appropriate exposure and visual effect.
~ A basic understanding of colour theory.
~ Documenation of images illustrating different filtration techniques.
~ Creation of images using technique, observation and selection
 demonstrating a practical understanding of filtration.

Introduction

The purpose of a filter is to selectively modify the light used for exposure. Filters are regularly used by professional photographers. They are an indispensable means of controlling the variations in light the photographer is likely to encounter. The range of filters used varies according to the range of situations likely to be encountered. However, when capturing RAW file images it is possible to undertake colour correction in post production. See 'Characteristics of Light'.

Studio

In the studio the photographer is able to create images with a consistent quality using few, if any, filters. The photographer must simply ensure the film stock or image sensor white balance is carefully matched to the light source being used. The studio photographer has the option of filtering the light source, the camera lens or placing the filters between the lens and the image plane. If the photographer is using a mixture of light sources the photographer should ideally filter the light at its source. Any filter attached to the camera lens must be of premium quality - preferably glass.

Location

On location where ambient light is the primary light source or cannot be eliminated from the overall exposure the necessity to carry and use a broad range of filters increases.

If choosing to purchase filters for lenses the photographer needs to be aware of the thread size on the front of each lens intending to be used. Filter sizes for fixed focal length, wide angle and standard lenses on 35mm and DSLR cameras are usually between 48 and 55mm. Medium-format, telephoto and zoom lenses may have thread sizes much larger. Purchasing every filter for every lens would be an expensive operation, so filters have to be selected carefully through actual rather than perceived need. Plastic filters are available from manufacturers such as 'Cokin' which can be adapted to fit a range of different lens diameters. The initial outlay to filter all lenses can be greatly reduced, but their working life may be far less due to the greater risk of damage.

Basic colour theory

To be comfortable with filtration it helps to understand basic colour theory. The broad spectrum of visible light is divided into three primary colours and three secondary colours. The primary colours of light are red, green and blue (RGB).

The secondary colours are yellow, cyan and magenta. When used in the printing industry to create images black is added (CMYK or four-colour printing).

Each secondary colour is a combination of two primary colours and is 'complementary' to the third primary.

- ~ Yellow is complementary to blue
- ~ Cyan is complementary to red
- ~ Magenta is complementary to green

photographic lighting >>> essential skills >>>

Filter categories

Filters can be divided into five main categories:

~ Neutral filters
~ Black and white
~ Colour conversion
~ Colour balancing
~ Effects.

Neutral filters

A range of filters are manufactured that have little or no colour. These include:

~ UV (haze) and 'skylight' filters (clear)
~ Neutral density filters (grey)
~ Polarising filters (grey).

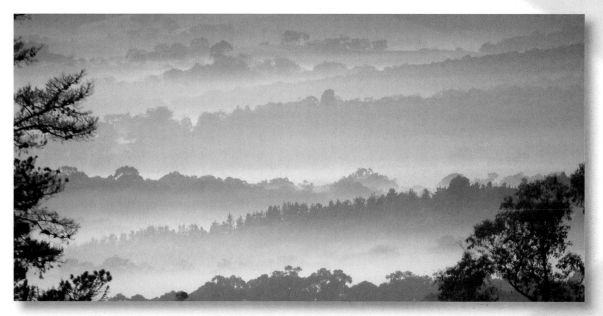

Mark Galer

UV and skylight filters

Ultraviolet (UV) radiation present in the spectrum of light is invisible to human vision but adds to the overall exposure of the image. It is most noticeable with landscape images taken at high altitude and seascapes. To ensure the problem is eliminated, UV filters can be attached to all lenses used on location. If the optical quality of the filter is good the filters may be left permanently attached to the lenses. The added benefit of this practice is the front lens element of each lens will be protected from scratching.

A skylight filter also eliminates UV light and has a colour compensating effect. Shadows filled by skylight have a blue cast and the slightly pink filter helps to create shadows with a neutral colour cast. Skylight filters are identified as a 1A and a stronger 1B.

Neutral density filters

With manufacturers going to great lengths to create fast lenses with wide maximum apertures it may seem strange to find a range of filters available which reduce the amount of light at any given aperture. These are neutral density filters and are available in a range of densities. If only one is purchased the photographer should consider one that can reduce the light by at least two stops (four times less light). Neutral density filters are used for two reasons:

~ Reducing depth of field
~ Increasing duration of exposure.

Reducing depth of field

Very shallow depth of field is not always possible when working on location if the ambient light is very bright. If the photographer is using an ISO setting of 100 and direct sunlight to illuminate the subject the photographer may only be able to select f5.6 or f8 as their maximum aperture, if the maximum shutter speed available on the camera being used is 1/1000 or 1/500 second. This aperture may not be enough to sufficiently isolate the subject. If the aperture was increased further overexposure would result. The problem can be solved by using a lower ISO, a camera with a focal plane shutter capable of exceeding 1/1000 second, or a neutral density filter.

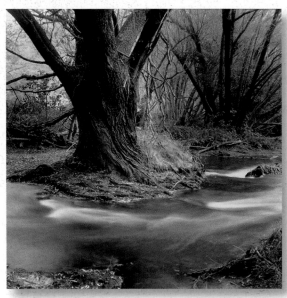

Duration of exposure - Martina Gemmola

Reduced depth of field - Samantha Everton

Increasing duration of exposure

Long exposures are not always possible when working on location if the ambient light is bright. If the photographer is using a film or image sensor at 100 ISO and direct sunlight to illuminate the subject the photographer may only be able to select 1/60 or 1/30 second as their slowest shutter speed, if the minimum aperture on the camera lens is f22 or f32. This shutter speed may not be sufficient to give the movement blur required. The problem can be solved by using a lower ISO, a lens with a minimum aperture smaller than f32 or a neutral density filter.

Polarising filters

Polarised light is the light reflected from non-metallic surfaces and parts of the blue sky. A polarising filter can reduce this polarised light and the effects are visible when viewing the image in the camera.

A polarising filter is grey in appearance and when sold for camera use consists of the actual filter mounted onto a second ring, thus allowing it to rotate when attached to the lens. The filter is simply turned until the desired effect is achieved.

The polarising filter is used for the following reasons:

~ Reduces or removes reflections from surfaces
~ Darkens blue skies at a 90 degree angle to the sun
~ Increases colour saturation.

Mark Galer

Possible problems

The filter should be removed when the effect is not required. If not removed the photographer will lose two stops and reduce the ability to achieve overall focus.

When the polarising filter is used in conjunction with a wide-angle lens, any filter already in place should be removed. This will eliminate the problem of tunnel vision or clipped corners in the final image. Photographing landscapes when the sun is lower in the sky can result in an unnatural gradation, ranging from a deep blue sky on one side of the frame to a lighter blue sky on the other.

ACTIVITY 1

Create an image on a sunny day eliminating polarised light and one without using the filter.
Try to remove reflections from a shop window using a polarising filter.
How effective is the filter at eliminating these reflections?
Compare and contrast your results with other students.

Black and white filters

When the photographer is using black and white film there is the option of controlling tonal values and contrast by using coloured filters, e.g. a green apple and an orange may record on black and white film with the same tonal value or shade of grey. The use of an orange filter would result in the orange recording lighter and the apple darker; using a green filter would result in the apple recording lighter and the orange darker. Filters lighten their own colour. In this way the tones are made different.

Many photographers using black and white film use a yellow/green filter as standard to correct the bias of the film towards the blue end of the spectrum.

The basic rule when using coloured filters with black and white film is:

Adjacent colours are lightened.
Opposite colours are darkened.

Using the colour wheel on the right, the photographer can quickly determine that colours the same as the filter and either side of the filter colour will be lightened. All others will be darkened.

The colour wheel

Black and white filters

Code	Colour	Filter factor	Effect
Y2	Yellow	2	Reduces exposure of blue sky.
G	Green	4	As for Y2 plus lightens green foliage and renders good skin tones for daylight portraits.
YG	Yellow/Green	2	Corrects tones to that of human vision.
O2	Orange	4	Blue skies record as middle tones.
R2	Red	8	Creates dark and dramatic skies. Underexposes green foliage.

ACTIVITY 2

Using black and white film or grayscale/black and white capture mode produce a landscape image using one of the filters from the 'Black and white filter chart' above.

Take a control image without the use of a filter for comparison.

Discuss your findings with other students.

Colour conversion filters

The definition of a colour conversion filter is one used to convert the colour temperature of various light sources to match the colour balance of the film being used. When capturing RAW file images it is possible to undertake colour correction in post production. See 'Characteristics of Light'.

Tungsten light

The filters used for this purpose are the 80 series including the 80A and 80B. These filters are blue in colour and are used to balance daylight film with tungsten light sources. The 80B is used mainly in a studio situation to balance daylight film with photoflood bulbs specifically made for photographic lighting purposes.

	Daylight	3400K	3200K
Daylight film	None	80B	80A
Tungsten film	85B	81A	None

Colour conversion chart

When using film a location photographer should have an 80A filter available. This filter allows daylight film to be used with tungsten-halogen lamps and record with approximately neutral tones. If daylight film is used in conjunction with an 80A filter and ordinary household light bulbs the resulting transparencies will still have a slightly warm cast.

A problem associated with using an 80A filter is the loss of two stops (filter factor 4). The photographer prepared for this will usually carry a 400 ISO film which they are prepared to push if necessary.

Fluorescent light

It is very difficult to assess the colour cast that will result when fluorescent lights are illuminating the subject. Most images record with a green cast and most conversion filters are predominantly magenta coloured with additional yellow or cyan filtration. An FLD filter is marketed for use with fluorescent lights and daylight film but it usually only improves rather than rectifies the situation.

With six main types of fluorescent lights commercially available all requiring different colour conversions the best advice to a photographer is to:

Switch fluorescent lights off if possible.

Photographers leaving fluorescent lights on run the risk of a heavy colour cast. This is often an oversight or the photographer may think the fluorescent lights are contributing little to the overall illumination and knowingly leave them on. The result is often devastating. Individuals with fair hair appear with bright green sprouting tufts from the tops of their heads and the tubes if in the frame appear as bright green.

Colour balancing filters

Colour balancing filters are used to produce more subtle changes in the colour balance of the final image. They are particularly useful when working on location using colour transparency film. The most common light-balancing filters used are the 81 and 82 series filters. The 81 series are warm in colour (yellow) and the 82 series are cool in colour (blue). The subtlest changes are made with the straight 81 or 82 filter, the A, B and C becoming progressively stronger. Exposure compensation is between one-third and two-thirds of one stop.

Warmer						Neutral	Cool			
81EF	81D	81C	81B	81A	81	*	82	82A	82B	82C

Warm ... Cool ... Cooler

One or two filters from the 81 series are particularly useful for removing the blue cast recorded when photographing in overcast conditions or in the shadows present in full sun. See the colour correction chart in 'Characteristics of Light'.

Effects filters

Numerous special effects filters are available from camera stores. Most are a gimmick and once used are quickly discarded by the serious photographer. These include star-burst filters and graduated colour filters.

Probably the most commercially viable special effects filter is the soft focus filter or diffuser. This is especially useful in close-up portraiture where the photographer wants to create a flattering portrait but the sitter has a somewhat less than perfect complexion.

Effects with standard coloured filters

Many special effects can be created with conventional colour filters and a little imagination. These include using a coloured filter over the light source and a complementary filter on the camera lens. The effect is a neutral toned foreground with a background that bears the colour cast of the filter on the camera lens.

Another effect is obtained by mounting a camera on a tripod and taking three exposures of moving subjects on the same piece of film. If the photographer uses a different primary coloured filter (25 red, 61 green and 38A blue) for each of the exposures the effect is a near neutral background with coloured moving subjects. Take a meter reading without the filters attached and open up one stop for each of the three exposures.

ACTIVITY 3

Create an image using an effects filter or filters. If you do not have access to an effects filter create your own using a piece of glass, perspex or Gladwrap.

Place on the lens and alter the transmission of light by modifying the surface of the material chosen (smearing the glass or perspex with Vaseline or stretching the Gladwrap).

Experiment and discuss your findings with other students.

Filter factors

Filter factors are indications of the increased exposure necessary to compensate for the density of the filter. A filter factor of two indicates the exposure should be doubled (an increase of one stop). A filter factor of four indicates the exposure should be increased four-fold (two stops) and eight requires three stops increased exposure.

Establishing an appropriate exposure

When using a camera with TTL metering the light meter is reading the reduced level of transmitted light and so theoretically the exposure should require no compensation by the photographer. In practice, when using the deeper colour filters and TTL metering, it is advisable to take a meter reading before the filter is attached to the lens and then apply the filter factor. This leads to more accurate exposures being obtained as the meter can be misled by the coloured light if metering through the filter.

Using more than one filter

Remove UV or skylight filters when using other filters. All filters provide UV filtration. Beware of vignetting or cropping the corners of the image when using multiple filter combinations.

When using two filters the combined filter factors should be multiplied not added. If a neutral density filter with a filter factor of four is used in conjunction with an orange filter, also with a filter factor of four, the resulting filter factor would be sixteen, not eight. Adding the filter factors instead of multiplying them would lead to a one stop underexposure.

Filter factor table

Filter factor	Exposure increase in stops	Density
1.25	⅓	0.1
1.5	⅔	0.2
2	1	0.3
2.5	1 ⅓	0.4
3	1 ⅔	0.5
4	2	0.6
5	2 ⅓	0.7
6	2 ⅔	0.8
8	3	0.9
10	3 ⅓	1.0

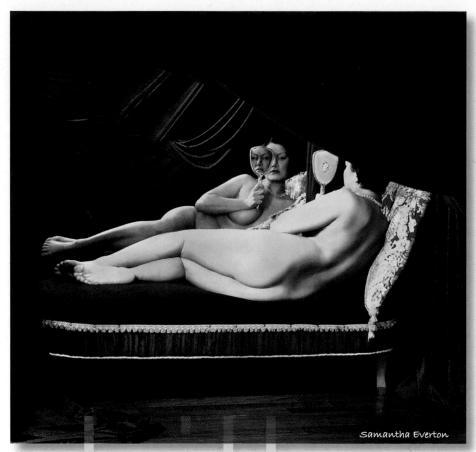

Samantha Everton

skill ap

application module>>

lighting on location

Mark Galer

essential skills

~ Change the character and mood of subject matter using lighting.
~ Develop an awareness of overall subject contrast and how this is translated by the capture medium.
~ Develop skills in controlling introduced lighting on location.
~ Develop ideas - produce research in your Visual Diary looking at a broad range of fill and flash lighting techniques.
~ Produce photographic images demonstrating how lighting techniques control communication.

Introduction

The lighting in a particular location at any given time may not be conducive to the effect the photographer wishes to capture and the mood they wish to communicate. In these instances the photographer has to introduce additional lighting to modify or manipulate the ambient light present. In some instances the ambient light becomes secondary to the introduced light, or plays little or no part in the overall illumination of the subject. The following conditions may lead a photographer towards selecting additional lighting:

~ The lighting may be too dull and the resulting slow shutter speeds would cause either camera shake or subject blur.
~ Colour temperature of artificial lights causing undesired colour casts.
~ The ambient light is leading to an unsuitable brightness range for the film or image sensor, e.g. the contrast is too high for the latitude of the capture medium and would lead to either overexposed highlights or underexposed shadows.
~ The direction of the primary light source is giving unsuitable modelling for the subject, e.g. overhead lighting creating unsuitable shadows on a model's face.

Shane Bell

ACTIVITY 1

Select four images created on location where you feel the photographer has used additional lighting to the ambient light present.
Discuss why you think the lighting has been changed to suit the communication.

Fill

In high and extreme contrast scenes where the subject brightness range exceeds the latitude of the imaging sensor or film, it is possible for the photographer to lower the overall lighting ratio by supplying additional fill-light. The two most popular techniques include using reflectors to bounce the harsh light source back towards the shadows or by the use of on-camera flash at reduced power output. Before the photographer jumps to the conclusion that all subjects illuminated by direct sunlight require fill, the photographer must first assess each scene for its actual brightness range. There can be no formula for assessing the degree of fill required when the subject is illuminated by direct sunlight. Formulas do not allow for random factors which are present in some situations but not in others. Photographers must, by experience, learn to judge a scene by its true tonal values and lighting intensity.

Mark Galer

The photograph above was taken in Morocco in harsh sunlight. The photographer could be mistaken for presuming this is a typical scene which would require fill-light. If the scene is read carefully however the photographer would realise that the shadows are not as dark as one would presume. Meter readings taken in the shadows and highlights would reveal that the shadows are being filled by reflected light from the brightly painted walls.

Reflectors

Fill-light can occur naturally by light bouncing off reflective surfaces within the scene. It can also be introduced by reflectors strategically placed by the photographer. This technique is often used to soften the harsh shadows cast on models in harsh sunlight.

The primary considerations for selecting a reflector are surface quality and size.

Natural fill - Mark Galer

Surface quality

Reflectors can be matt white, silver or gold depending on the characteristics and colour of light required. A matt white surface provides diffused fill-light whilst shiny surfaces, such as silver or gold, provide harsher and brighter fill-light. Choosing a gold reflector will increase the warmth of the fill-light and remove the blue cast present in shadows created by sunlight.

Size

Large areas to be filled require large reflectors. The popular range of reflectors available for photographers are collapsible and can be transported to the location in a carrying bag. A reflector requires a photographer's assistant to position the reflector for maximum effect. Beyond a certain size (the assistant's ability to hold onto the reflector on a windy day) reflectors are often not practical on location.

ACTIVITY 2

1. Select four examples where fill-light has been used to soften the shadows created by a harsh direct light source. Comment on the likely source of the fill-light used in each image.

2. Create an image by experimenting with different reflectors to obtain different qualities of fill-light. Keep a record of the type of reflector used with each image and the distance of the reflector from the subject.

photographic lighting

>>>

>>>

>> essential skills >>>

Flash

Flash is the term given for a pulse of very bright light of exceptionally short duration. The light emitted from a photographic flash unit is balanced to daylight and the duration of the flash is usually shorter than 1/500 second.

When the photographer requires additional light to supplement the daylight present flash is the most common source used by professional photographers. Although it can be used to great effect it is often seen as an incredibly difficult skill to master. It is perhaps the most common skill to remain elusive to students of photography when working on location. Reviewing the image digitally or using Polaroids will help the photographer master the skills more quickly. The flash is of such short duration that integrating flash with ambient light is a skill of previsualisation and applied technique. The photographer is unable to make use of modelling lights that are used on studio flash units (modelling lights that can compete with the sun are not currently available). The skill is therefore mastered by a sound understanding of the characteristics of flashlight and experience through repeated application.

Shane Bell

Characteristics

Flash is a point light source used relatively close to the subject. The resulting light is very harsh and the effects of fall-off (see 'Characteristics of Light') are often extreme. One of the skills of mastering flash photography is dealing with and disguising these characteristics that are often seen as professionally unacceptable.

Choice of flash

Choosing a flash unit for use on location may be decided on the basis of degree of sophistication, power, size and cost.

Most commercially available flash units are able to read the reflected light from their own flash during exposure. This feature allows the unit to extinguish or 'quench' the flash by a 'thyristor' switch when the subject has been sufficiently exposed. When using a unit capable of quenching its flash, subject distance does not have to be accurate as the duration of the flash is altered to suit. This allows the subject distance to vary within a given range without the photographer having to change the aperture set on the camera lens or the flash output. These sophisticated units are described as either 'automatic' or 'dedicated'.

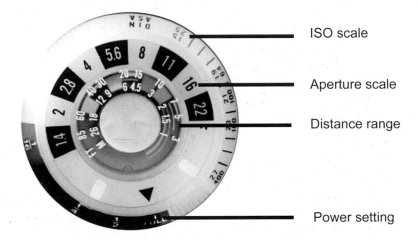

ISO scale

Aperture scale

Distance range

Power setting

Control panel of an older style automatic flash unit

Automatic

An automatic flash unit uses a photocell mounted on the front of the unit to read the reflected light and operate an on-off switch of the fast acting thyristor type. The metering system works independently of the camera's own metering system. If the flash unit is detached from the camera the photocell must remain pointing at the subject if the exposure is to be accurate.

Useful specifications

Perhaps the most important consideration when selecting an automatic flash unit is its ability to make use of a range of f-stops on the camera lens. Cheaper units may only have a choice of two f-stops whereas more sophisticated units will make use of at least four.

Ideally the output of a professional unit will have a 'guide number' (an indication of the light output) of 25 or more. The amount of time the unit takes to recharge is also a consideration. Many flash outfits have the option of being linked to a separate power pack so that the drain on the unit's smaller power supply (usually AA batteries) does not become a problem.

The flash head of a unit will ideally swivel and tilt, allowing the photographer to direct the flash at any white surface whilst still keeping the photocell pointed at the subject.

Dedicated

Dedicated flash units are often designed to work with specific cameras, e.g. Nikon 'speedlights' with Nikon cameras. The camera and flash communicate more information through additional electrical contacts in the mounting bracket of the unit. The TTL metering system of the camera is used to make the exposure reading instead of the photocell. In this way the exposure is more precise and allows the photographer the flexibility of using filters without having to alter the settings of the flash.

In addition to the TTL metering system the camera may communicate information such as the ISO of the capture medium and the focal length of the lens being used. This information may be automatically set, ensuring an accurate exposure and the correct spread of light.

Features such as automatic fill flash, slow sync, rear curtain slow sync, red eye reduction and strobe are common features of some sophisticated units. Often the manuals accompanying these units are as weighty as the manual for the camera which they are designed to work in conjunction with.

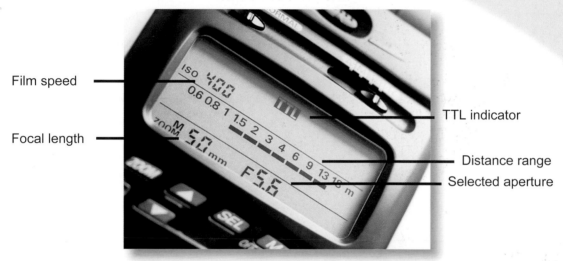

Film speed

Focal length

TTL indicator

Distance range

Selected aperture

Control panel of a modern dedicated flash unit

Setting up a flash unit

Check that the ISO has been set on either the flash or flash meter and the camera.

Check that the flash is set to the same focal length as the lens. This may involve adjusting the head of the flash to ensure the correct spread of light.

Check that the shutter speed on the camera is set to the correct speed (usually slower than 1/125 second on a 35mm SLR film camera using a focal plane shutter).

Check that the aperture on the camera lens matches that indicated on the flash unit. On dedicated units you may be required to set the aperture to an automatic position or the smallest aperture.

Check that the subject is within range of the flash. On dedicated and automatic units the flash will only illuminate the subject correctly if the subject is within the two given distances indicated on the flash unit. If the flash is set incorrectly the subject may be overexposed if too close and underexposed if too far away. Check the accuracy of the flash output using a flash meter (see 'Guide numbers' in this study guide).

Guide numbers

Portable flash units designed to be used with small-format and medium-format cameras are given a 'guide number' (GN) by the manufacturers. This denotes its potential power output. The guide number is an indication of the maximum distance at which the unit can be used from the subject to obtain an appropriate exposure. The guide number is rated in metres at 100 ISO and an aperture of f1. Because very few photographers possess an f1 lens the actual maximum working distance is usually somewhat lower than the guide number would suggest.

A unit given a guide number of 32 could correctly expose a subject at 16 metres using an aperture of f2 (32 divided by 2 = 16). If the lens was changed to one with a maximum aperture of f4, the maximum working distance would be reduced to eight metres.

It therefore follows that if the guide number of the unit is known the correct exposure can be determined by dividing the guide number by the working distance. The resulting figure is the aperture required when the flash is turned to manual full power (photocell effectively switched off). For example, a flash with a guide number of 32 used to expose a subject four metres away will require an aperture of f8.

Calculating guide number, distance and aperture

Distance from subject x Indicated aperture (MIE) = Guide number

Guide number ÷ Aperture = Effective working distance

Guide number ÷ Distance from subject = Correct aperture

ACTIVITY 3

Test the guide number of a flash unit using the following technique. The unit does not have to be attached to a camera.

Turn the flash unit to manual operation and full power.

Stand a measured distance from the flash unit, e.g. four metres.

Attach an invercone to the flash meter's cell and set the ISO to 100 .

Aim the flash meter at the unit and take an ambient reading of the flash (use a 'sync lead' or friend to manually trigger the flash using the test button).

Multiply the indicated aperture on the flash meter by the distance used, e.g. if the subject stands four metres from the flash and records a meter reading of f11 the guide number of the unit is 44.

Note > If no flash meter is available increase the distance between the flash and the subject at one metre intervals. Choose the best exposure and apply the calculation from 'Calculating guide number, distance and aperture'.

Flash as the primary light source

The direct use of flash as a professional light source is often seen as unacceptable due to its harsh qualities. The light creates dark shadows that border the subject, hot spots in the image where the flash is directed back into the lens from reflective surfaces and 'red-eye'.

Red-eye

Red-eye is produced by illuminating the blood-filled retinas at the back of the subject's eyes with direct flash. The effect can be reduced by exposing the subject's eyes to a bright light prior to exposure ('red-eye reduction') or by increasing the angle between the subject, the camera lens and the flash unit. Red-eye is eliminated by moving closer or by increasing the distance of the flash unit from the camera lens. To do this the lens must be removed from the camera's hotshoe. This is called 'off-camera flash'.

Off-camera flash

Raising the flash unit above the camera has two advantages. The problem of red-eye is mostly eliminated. Shadows from the subject are also less noticeable.

When the flash unit is removed from the camera's hot shoe the flash is no longer synchronised with the opening of the shutter. In order for this synchronisation to be maintained the camera and the flash need to be connected via a 'sync lead'.

For cameras that do not have a socket that will accept a sync lead a unit can be purchased which converts the hot shoe on the camera to a sync lead socket. If a dedicated flash unit is intended to be used in the dedicated mode a dedicated sync cable is required that communicates all the information between the flash and the camera. If this is unavailable the unit must be switched to either automatic or manual mode.

Keep the photocell of an automatic unit directed towards subject during exposure.

Hot-spots

When working with direct flash the photographer should be aware of highly polished surfaces such as glass, mirrors, polished metal and wood. Standing at right angles to these surfaces will cause the flash to be directed back towards the cameras lens, creating a hot-spot. Whenever such a surface is encountered the photographer should move so that the flash is angled away from the camera. It is a little like playing billiards with light.

ACTIVITY 4

Connect a flash unit to your camera via a sync lead and set the unit to automatic.

Position your subject with their back to a white wall (within half a metre).

Hold the flash above the camera and directed towards the subject.

Make exposures at varying distances from the subject. Keep a record of the position of the flash and distance from the subject.

Repeat the exercise with the unit mounted on-camera.

Discuss the results of the most favourable image, commenting on the light quality, shadows and the presence of red-eye.

91

Diffusion and bounce

If the subject is close or the output of the flash unit is high, the photographer has the option of diffusing or bouncing the flash. This technique will soften the quality of the light but lower the maximum working distance.

Diffusion

Diffusion is affected by placing tissue, frosted plastic or a handkerchief over the flash head. Intensity of light is lowered but the quality of light is improved. The flash can be further diffused by directing the flash towards a large, white piece of card attached to the flash head. Purpose-built attachments can be purchased.

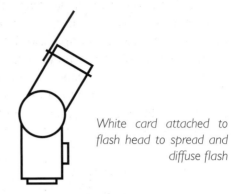

White card attached to flash head to spread and diffuse flash

Bounce flash

The most subtle use of flash is achieved by directing the flash to a much larger, white reflective surface such as a ceiling for overhead lighting, or nearby wall for side lighting. This is called bouncing the flash. To obtain this effect the flash unit must have the ability to tilt or swivel its flash head. If this is not possible the flash can be removed from the hot shoe and connected to the camera via a sync lead. If an automatic flash is being used the photographer must ensure that the photocell is facing the subject when the flash is fired.

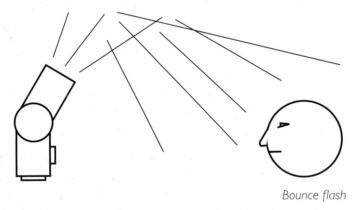

Bounce flash

ACTIVITY 5

Create an image of a person using either diffused flash or bounce flash. For the bounce flash technique direct the flash towards a white ceiling or white reflector positioned to one side of the subject. Vary the distances of the reflector to the subject. Discuss and compare the quality of the light in your resulting image or images.

Note > Ensure the thyristor of the flash unit is directed towards your subject.
Alternatively use a flash meter to establish an appropriate exposure.

Fill-flash

Fill-flash can be a very useful way of lowering the brightness range. Often the photographer is unable to reposition the primary subject and the addition of fill-light from the camera's position is essential to the image's success.

The aim of fill-flash is to reveal detail in the dark shadows created by a harsh directional light source. The aim is not to overpower the existing ambient light and remove the shadows completely. If the power of the flash is too high the light will create its own shadows creating an unnatural effect. Because the ambient light is still regarded as the primary light source any exposure dictated by the flash unit must also be suitable for the ambient light.

Mount the flash unit on the camera's hot shoe and direct the flash towards the subject. To retain the effect of the primary (ambient) light source the flash is most commonly fired at half or quarter power. The ratio of ambient to flash light is therefore 2:1 or 4:1.

Ambient light only 4:1 ratio 1:1 ratio

Manual - Select a smaller aperture on the camera from that indicated by the flash unit or flash meter, e.g. if the meter or unit indicates f5.6 select f8 or f11 on the camera.

Automatic - Many automatic flash units have the facility to fire at 1/2 or 1/4 power, making fill-flash a relatively simple procedure. If this facility is unavailable set the ISO on the flash unit to double or quadruple the actual speed of the film or image sensor to lower the output.

Dedicated - Many sophisticated cameras and dedicated flash units have a fill-flash option. This should be regarded as a starting point only and further adjustments are usually required to perfect the technique. Power often needs to be further lowered for a more subtle fill-in technique. The photographer may also wish to select a 'slow-sync' option on the camera, if available, to avoid underexposing the ambient light in some situations.

ACTIVITY 6

Create an image using the fill-flash technique.

Lower the lighting contrast of a portrait lit with harsh sunlight.

The subject should be positioned so that the ambient light is from above, from the side or from the back.

Experiment to see if you can lower the flash output on your unit to half or quarter power.

Discuss the light quality of the resulting image and the fill/ambient lighting ratio.

Flash as a key light

The main light in studio photography is often referred to as the 'key light'. Using studio techniques on location is popular in advertising and corporate photography where mood is created rather than accepted. In this instance flash becomes the dominant light source and the ambient light serves only as the fill-light.

When the ambient light is flat, directional light can be provided by off-camera flash. This enables the photographer to create alternative moods. The use of off-camera flash requires either the use of a 'sync lead' or an infrared transmitting device on the camera.

Slave units

Some professional flash units come equipped with a light-sensitive trigger so that as soon as a flash connected to the camera is fired the unconnected flash or 'slave' unit responds. On location the slave unit can be fired by the use of a low powered on-camera flash.

Accessories

A tripod or assistant is required to either secure or direct the flash.

An umbrella or alternative means of diffusion for the flash may be considered.

Colour compensating filters may also be considered for using over the flash head. A warming filter from the 81 series may be useful to create the warming effect of low sunlight.

Technique

- Check the maximum working distance of the flash.
- Ensure the key light is concealed within the image or out of frame.
- Diffuse or bounce the key light where possible.
- Consider the effects of fall-off.
- Avoid positioning the key light too close.
- Establish a lighting ratio between the key light and ambient light.
- Consider the direction of shadows being cast from the key light.

When working at night the photographer may have the option of approaching the subject and firing a number of flashes manually during an extended exposure (recharging the unit each time). The photographer or assistant must take care not to illuminate themselves during this process.

ACTIVITY 7

Create an image using introduced light as a directional key light.

Record the lighting ratios between the key light and the ambient light present.

Discuss the effects of both the key and ambient light on your subject.

Slow-sync flash

Slow-sync flash is a technique where the freezing effect of the flash is mixed with a long ambient light exposure to create an image which is both sharp and blurred at the same time. Many modern cameras offer slow-sync flash as an option within the flash programme but the effect can be achieved on any camera. The camera can be in semiautomatic or manual exposure mode. A shutter and aperture combination is needed that will result in subject blur and correct exposure of the ambient light and flash. To darken the background so that the frozen subject stands out more, the shutter speed can be increased over that recommended by the camera's light meter.

~ Set the camera to a low ISO setting or use 100 ISO film or less.
~ Select a slow shutter speed to allow movement blur, e.g. 1/8 second.
~ Take an ambient light meter reading and select the correct aperture.
~ Set the flash unit to give a full exposure at the selected aperture.
~ Pan or jiggle the camera during the long exposure.

Mark Galer

Possible difficulties

Limited choice of apertures - less expensive automatic flash units have a limited choice of apertures leading to a difficulty in obtaining a suitable exposure. More sophisticated units allow a broader choice, making the task of matching both exposures much simpler.

Ambient light too bright - if the photographer is unable to slow the shutter speed down sufficiently to create blur, a slower film should be used or the image created when the level of light is lower.

ACTIVITY 8

Create an image using the technique slow-sync or flash-blur.
Choose a subject and background with good colour or tonal contrast.
Pan the camera during the exposure.
Discuss the results.

Orien Harvey

the zone system

Mark Galer

essential skills

~ Control the resulting tonal range of a black and white image using black and white film.
~ Learn to previsualise the printed image when viewing a scene.
~ Test the exposure index of the film you are using.
~ Test the accuracy of the development you are using.
~ Create images exposing for the shadows and processing for the highlights.

Introduction

The zone system is a technique of careful metering, exposure, processing and printing designed to give maximum control over the resulting tonal values of a black and white image that has been captured using black and white film. It is an appropriate technique to use on location where the ambient light cannot be altered to suit the contrast and tonal range desired by the photographer. It requires the use of short rolls of film or sheet film as the film processing has to be tailored to suit the subject contrast and lighting quality of each specific image.

The system was developed by the famous landscape photographer Ansel Adams. He formulated that just as an octave of audio frequency can be subdivided into notes from A to G#, the tonal range of the image (from black to white) can also be subdivided into tones or zones, each zone being one stop lighter or darker than the next. The zones on the photographic paper can be measured and are not open to interpretation. The zone system can, however, be used to interpret the subject differently depending on the desired outcome by the photographer. The photographer achieves this by choosing how dark or light the highlight and shadows tones will appear in the final printed image. 'Previsualisation' is the term given to the skill of being able to see in the mind's eye the tonal range of the final print whilst viewing the subject. The zone system removes any surprise factor involved in the resulting tonal range of the image.

Arches - Ansel Adams © Ansel Adams Publishing Rights Trust/Corbis

Benefits and limitations

With practice the photographer needs only to take one exposure to translate the subject into a preconceived image. Ansel Adams did not bracket his exposures. He did not need to. He knew precisely the result that each exposure would produce.

The time it takes to meter the subject carefully limits the use of the system. Images are created using the zone system, not captured. Henri Cartier-Bresson would not have found Ansel's zone system very useful for the images he wished to make.

photographic lighting >>>

essential skills >>> >>>

Zone placement

Many photographers already use one aspect of the zone system when they take a light meter reading. Taking a reflected meter reading from a grey card and exposing the film to that meter indicated exposure is to place a tone (middle grey) to a specific zone (Zone V). The placing of a tone to a specific zone is called 'zone placement'.

To use the zone system fully the photographer must take two readings when metering the subject. One reading is taken from a highlight and one from a shadow. They are chosen by the photographer as the brightest and darkest tones which will require detail when these tones are viewed in the final image. These tones are selected subjectively. Each photographer may choose different highlight or shadow tones depending on the desired outcome. The selected highlight and shadow tones are then placed to appropriate zones.

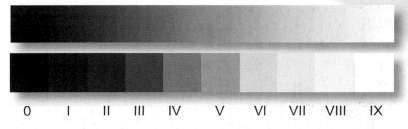

The zone ruler

The tonal range of the print is of course much greater than just ten tones. Breaking the tonal range into ten precise zones allows the photographer to visualise how a metered tone in the subject will translate into a tone on the printing paper.

A selected tone can be moved up or down the scale one zone at a time simply by opening or closing the aperture one stop at a time. By placing a tone further up or down the scale the image is made darker or lighter as all other tones are moved in the same direction.

ACTIVITY 1

Frame a location (one that you can revisit again easily) when it is illuminated by directional sunlight. Approach a broad range of tones, from bright highlights to dark shadows, within the framed image and take a reflected light meter reading from each. Keep a record of each tone and its meter indicated exposure.

Take a grey card reading and bracket three exposures (meter indicated exposure, plus one stop and minus one stop). Process the film normally using the manufacturer's recommended development time, temperature and frequency of agitation.

Make a print from each of the three negatives without burning the highlights or dodging the shadows on medium-contrast printing paper. Using your notes label the range of tones you metered for in the first step of this activity, e.g. you may label a dark tone f4 @ 1/125 second and a highlight as f16 @ 1/125 second.

Discuss the tonal quality of each print with other students, e.g. can you see detail in the highlights and shadows?

Contrast control

The individual tones within the subject can be moved closer together (lowering the contrast) by reducing the processing time, or moved further apart (increasing the contrast) by increasing the processing time. Decreasing the processing time decreases the density of the highlights on the negative whilst leaving the shadow tones relatively unaffected. Increasing the processing time increases the density of the highlight tones on the negative whilst leaving the shadow tones relatively unaffected. There is some effect on the mid-tones in both instances but proportionally less than the highlights.

If shadows are missing from the negative (areas of clear film base within the frame) then no amount of extra development will reveal detail in these areas.

Negative with good detail

Contrast exceeding the latitude of the film

Subject brightness range

The photographer can measure the contrast of the subject (subject brightness range) and then alter the processing of the negatives according to the desired contrast. The photographer exercises precise control by measuring the distance in stops between a highlight tone and shadow tone. If the distance between the selected highlight and shadow tones is greater than four stops (extreme contrast) processing can be decreased to lower the contrast of the image. If the distance between the selected highlight and shadow tones is less than four stops the processing can be increased to increase the contrast of the image.

> ## *SUMMARY SO FAR*
> * The zone system is made up of ten major tones from black to white.
> *. Each tone is one stop darker or lighter than the next.
> * Specific highlight and shadow tones of the subject are assigned to specific zones.
> * Zone placement of a shadow tone is a subjective decision. The decision dictates what detail is visible and how dark these shadows appear in the final image.
> * Development affects highlight tones proportionally more than shadow tones.
> * Increased or decreased processing time leads to increased or decreased contrast.
> * Subject contrast is measured in stops.
> * Shadow tones are controlled by exposure and highlight tones by development.

The zones

Each zone in the final image can be identified by its tone and the detail it reveals.
To obtain accuracy we must become familiar with the characteristics of each zone.

Zone IX. Paper white. The standard print utilising a full tonal range uses little or no paper white in the image.

Zone VIII. White without detail. The brightest highlights in the image are usually printed to this zone.

Zone VII. Bright highlights with visible detail or texture. If highlight detail is required it is placed in this zone by calculated processing time.

Zone VI. Light grey. Caucasian skin facing the light source is usually printed as Zone VI.

Zone V. Mid-grey with 18% reflectance. A meter indicated exposure from a single tone will produce this tone as a Zone V on the negative.

Zone IV. Dark grey.
Shadows on Caucasian skin are usually printed as Zone IV.

Zone III. Dark shadow with full detail and texture. If shadow detail is required it is placed in this zone by calculated exposure.

Zone II.
Shadow without detail.

Zone I.
Black.

Zone O.
Maximum black and is indistinguishable from Zone I in the printed image.

ACTIVITY 2

Refer back to the three prints created for Activity 1.
Select the image with the broadest range of tones (best exposure).
Label this image with the zones from I to IX. Use the description of each zone on this page to help you identify each zone.
Compare and discuss your labelled image with those of other students.

Zone recognition

Using the description in the previous section we are now able to recognise what each zone looks like in the printed image. Zones III and VII are of particular interest as they will indicate the accuracy of how a photographer has utilised the zone system. Important areas of shadow and highlight detail will have been preserved whilst still utilising Zones II and VIII to give the print both depth and volume.

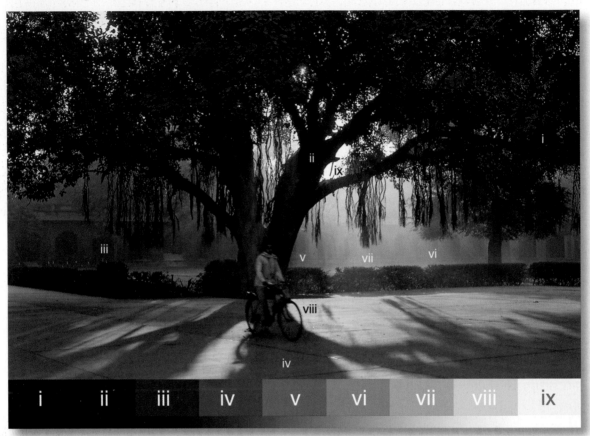

Zone III

Dark shadow with full detail and texture. If shadow detail is required it is placed in this zone by calculated exposure.

Zone VII

Bright highlights with visible detail or texture. If highlight detail is required it is placed in this zone by calculated processing time.

Operating the system

Gaining maximum control over the system requires practice. The student should take notes and compare the results with the actions taken. Mistakes may be made initially but these mistakes will lead to a greater understanding of the system.

Testing the accuracy of exposure and negative processing is crucial to obtaining precise control over the zone system. The photographer is advised to limit the combined choice of camera, light meter, film, developer, enlarger and printing paper until this control has been achieved, otherwise variations in outcome are inevitable.

Jana Liebenstein

Choice of camera, light meter and film

Use a camera and a light meter that provide accurate exposures. If the camera or meter receives a shock through impact, the equipment should be checked. Some retail outlets will offer to test the accuracy of the equipment.

Select only one type of 100 ISO film until control has been achieved. The student should ideally have some experience of processing this film prior to using it for the zone system. Establish an 'exposure index' for the film (see activity below). The usable speed for the film may vary from the manufacturer's recommended speed due to variety of reasons.

ACTIVITY 3

Using black and white negative film, take several exposures of a subject with a four stop range. Someone wearing a white shirt with dark trousers or jacket would be ideal. Calibrate the exposure using a reflected light meter reading taken from a grey card. The subject should be illuminated with diffused light (cloud cover or shade). Bracket the exposures (1/3 stop intervals) keeping a precise record of each frame.

Process the negatives according to the manufacturer's specifications.

View the negatives on a light box and choose the best exposure with the assistance of an experienced practitioner. The darkest tones of the subject should render full texture and detail (no area of the image should appear clear).

Choose the best exposure and check your records to find the degree of compensation required. For example, if the best exposures for accurately rendering shadow detail is 2/3 stop more than the manufacturer's recommendation of 100 ISO then proceed to rate the film at 2/3 stop less, i.e. 64 ISO.

photographic lights >>>

>> essential skills >>>

Exposure and processing

The zone system can be approached in a series of sequential steps. The entire system can be divided into two main practical skills. These are:

~ Exposing for the shadows.
~ Processing for the highlights.

Exposing for the shadows

View the subject and choose the dark shadows that you want to be able to see full detail and texture in when you view the final image. Take a specific reflected light meter reading from one of these dark shadow tones. Use a hand-held meter at close range or fill the frame of a 35mm SLR with the selected tone. Use a spot meter to isolate a tone from a distance.

Place the shadow tone in Zone III by stopping down two stops from your meter indicated exposure or MIE (e.g. if the light meter reading of the shadow tone is f4 @ 1/125 second then the final exposure could be f8 @ 1/125 second). This action is called 'exposing for the shadows'.

Note > The original meter reading is often taken in the form of an 'EV' (exposure value) reading so that the final exposure can be interpreted by different combinations of aperture and shutter speed.

Metering for the shadows and processing for the highlights

Processing for the highlights

View the subject and choose the bright highlights that you want to be able to see full detail and texture in when you view the final image. Take a specific reflected light meter reading from one of these bright highlights. Measure how many stops brighter the highlights are than the shadows metered for in the previous step. If the shadow tone meter reading was f4 @ 1/125 the highlight tone may measure f16 @ 1/125 (four stops difference).

For bright highlights to record as bright highlights with full detail and texture they must fall in Zone VII (four stops brighter than the shadows). If this is the case the negatives can be processed normally. If the highlights measure more or less than four stops, decrease or increase processing time accordingly (see 'Compression' and 'Expansion').

Adjusting the development time

It is recommended that 'one shot' development (tank development using freshly prepared developer which is discarded after the film is processed) is used in conjunction with a standard developer. Developers such as D-76 and ID-11 are ideal for this test.

The student should use the same thermometer of known accuracy (check it periodically with several others) and adhere to the recommended development times, temperatures and agitation. A pre-wash is recommended to maintain consistency.

Viewing the negatives - the highlights of a high-contrast subject should be dark but not dense when the negatives are viewed on a light box. Newspaper print slid underneath the negatives should easily be read through the darkest tones of the image. Manufacturer's numbers and identifying marks on pre-loaded film should appear dark but not swollen or 'woolly'. The student should view the negatives in the presence of an experienced practitioner to obtain feedback.

Compression

If the selected highlights measure five or six stops brighter than the shadows placed in Zone III they will fall in Zone VIII or IX respectively. No detail will be visible by processing and printing the negative normally. The highlight tones selected can be moved one or two zones down the scale to Zone VII by decreasing the processing time. This situation is often experienced with a high to extreme subject brightness range (SBR).

Moving the highlights one zone down the scale is referred to as N−1, moving the highlights two zones down the scale is referred to as N−2. N−1 negatives are processed for approximately 85% of the normal processing time, N−2 negatives for approximately 75% of the normal processing time when using 100 ISO film. The action of moving highlight tones down the zone scale is called 'compaction' or 'compression'. Shadow tones remain largely unaffected by reduced processing time so the final effect is to lower the contrast of the final negative.

Expansion

If the selected highlights measure only two or three stops brighter than the shadows they will fall in Zone V or VI respectively. Highlights will appear dull or grey if the negatives are processed and printed normally. The highlight tones selected can be moved one or two zones up the scale to Zone VII by increasing the processing time. This situation is often experienced with a low SBR or flat light.

Moving the highlights one zone up the scale is referred to as N+1, moving the highlights two zones up the scale is referred to as N+2. N+1 negatives are processed for approximately 130% of the normal processing time, N+2 negatives for approximately 150% of the normal processing time when using 100 ISO film. The action of moving highlight tones up the zone scale is called 'expansion'. Shadow tones remain largely unaffected by increasing the processing time so the final effect is to increase the contrast of the final negative.

Calibration tests

The following additional tests can be conducted to check the accuracy of exposure and processing time.

Note > Changing printing papers or type of enlarger (diffusion or condenser) will change the tonal range and contrast that can be expected and so therefore should be avoided.

Exposure

The exposure index is calibrated by checking the accuracy of shadow tones on the negative. This can be achieved by using a 'densitometer' or by conducting the following clip test.

- ~ Underexpose a grey card by three stops (Zone II).
- ~ Leave the adjacent frame unexposed.
- ~ Process the negatives according to the manufacturer's specifications.
- ~ Place half of each frame (unexposed and Zone II) in a negative carrier.

- ~ Make a step test using a normal contrast filter or grade two paper.
- ~ Establish the minimum time to achieve maximum black (MTMB).
- ~ The tone alongside the MTMB should appear as Zone II (nearly black).

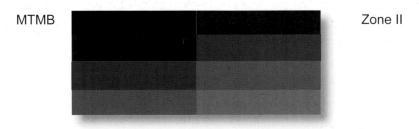

MTMB Zone II

If the adjacent tone to the MTMB exposure on the test strip is too light (dark grey), decrease the exposure of the film. If the adjacent tone to the MTMB exposure on the test strip is too dark (black), increase the processing time.

Processing

Processing is calibrated by checking the accuracy of the highlight tones on the negative.
This can be achieved by using a 'densitometer' or by conducting the following clip test.

~ Overexpose a grey card by three stops (Zone VIII).
~ Leave the adjacent frame unexposed.
~ Process the negatives according to the manufacturer's specifications.
~ Place half of each frame (unexposed and Zone VIII) in a negative carrier.

~ Make a step test using a normal contrast filter or grade two paper.
~ Establish the minimum time to achieve maximum black (MTMB).
~ The tone alongside the MTMB should appear as Zone VIII (light tone).

MTMB Zone VIII

If the adjacent tone to the MTMB exposure on the test strip is too light (paper white), decrease the
processing time of the film. If the adjacent tone to the MTMB exposure on the test strip is too dark
(Zone VII), increase the processing time.

ACTIVITY 4

Choose a 100 and 400 ISO film and conduct the exposure and processing tests as outlined on
these pages.
Discuss your findings with other students.

Perfecting the system

For accurate previsualisation the photographer must be familiar with all the materials and equipment in the chain of image creation. A common mistake is choosing a few very dark shadows to place in Zone III and the brightest highlights to place in Zone VII. The result may be a flat low-contrast image with the majority of the image placed in only three zones. Each time the system is operated the individual's ability to accurately previsualise the outcome improves.

Summary

- Take a reflected meter reading of a shadow tone.
- Place in zone III by closing down two stops.
- Take a reflected meter reading of a highlight tone.
- Calculate how many stops brighter the highlight is than the shadow.
- Calculate the processing time using the information below.

Average processing adjustments for 100 ISO film

Contrast		Processing time %
Highlight 6 stops brighter than Zone III	N+2	75
Highlight 5 stops brighter than Zone III	N+1	85
Highlight 3 stops brighter than Zone III	N−1	130
Highlight 2 stops brighter than Zone III	N−2	150

ACTIVITY 5

Revisit the location you photographed in Activity 1 at the same time of day with the same lighting (directional sunlight required).

Using the zone system create an image with a full tonal range.

Choose the shadow and highlight details you wish to place in Zone III and Zone VIII.

Expose, process and print the negative to obtain the final image.

Compare the results achieved in this activity with the image created for Activity 1 and discuss the visual qualities with other students.

photographic lighting

>> essential skills >>>

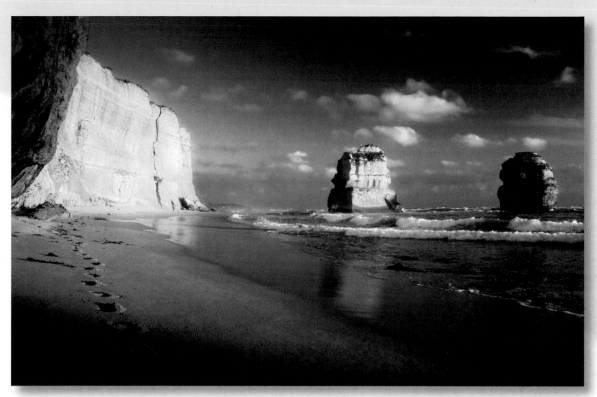

Mark Galer

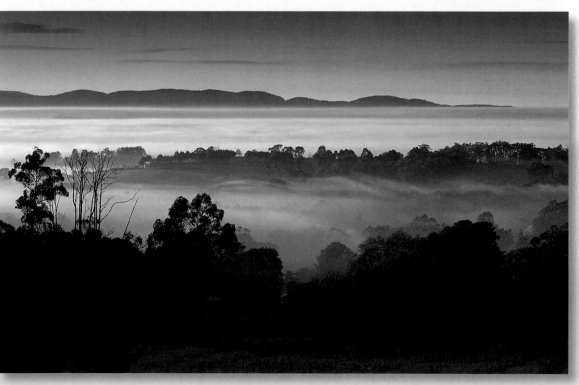

Mark Galer

109

Wil Gleeson

studio lighting

Samantha Everton

essential skills

~ Develop knowledge and understanding of the use of artificial light sources, camera and associated equipment in a studio environment.

~ Develop an awareness of the effect of artificial light in the creation and control of lighting ratios, shade, contrast and exposure.

~ Observe the importance of lighting in the production of photographic images.

~ Produce photographs demonstrating a practical knowledge of the use of light.

~ Compile information relevant to the technique and production of each image.

Introduction

This study guide should be used as a practical source of information to understanding the use of tungsten light and flash in a studio situation. The explanation of how to use the two main light source configurations (floodlight and spotlight) is directly related to providing practical lighting solutions to the activities. It will also provide a basis for completion of the structured assignments in *Essential Skills: Studio Photography*. It is advisable the technique and lighting approach suggested in each activity be initially followed and then adapted to individual subject matter.

Shaun Guest

Approach

The sun, the dominant light source in the world outside the studio, is the starting point to understanding studio lighting. As you progress through your photographic career other approaches will inevitably influence you but an understanding of how to use a single light source to achieve many varied results is a discipline worth mastering. Try not to attempt too much too soon. Set yourself goals you know you can achieve within your limitations. Aspiring photographers may never have enough time or money but admirably they are exploding with ideas. It is making these ideas work within these constraints and abilities that will give successful results. Set out to achieve what you know is possible, take as much time as is available and exercise patience. If you allow three hours to produce an image use the full three hours. When you have completed the photograph experiment with variations. Every time you move a light or alter its quality you will learn something. You will never take the perfect photograph. If you ever think you have change careers because photographically the learning process has ceased.

Studio lighting

In a photographic studio all light is created by the photographer. An artificial light source can be anything from a large 20kW tungsten lamp to a single candle. These light sources fall into four main categories.

- ~ Photoflood
- ~ Tungsten-halogen
- ~ AC discharge
- ~ Flash.

Photoflood (3400K)

The photoflood is similar in design to the normal domestic light globe. It is balanced to tungsten and normally used without correction. If balanced to daylight an orange colour cast will be evident. This can be corrected with the use of a blue (80B) filter or saving to RAW format. When used with black and white film slight underexposure will occur. As the name implies this type of lamp is used when a broad, soft light source is required.

Tungsten-halogen (3200K)

The most commonly used photographic artificial light. Light is emitted as the element inside the glass envelope is heated and provides a continuous source of light. All tungsten light forms emit a great deal of heat when operating. It is balanced to tungsten and normally used without correction. If balanced to daylight an orange colour cast will be evident. This can be corrected with the use of a blue (80A) filter or saving to RAW format. These lamps are mainly used where a point source of light is required (spotlight).

AC discharge (5600K)

Referred to as HMIs, AC discharge lamps have a very high output but emit less heat than tungsten when operating. They will maintain correct colour balance throughout the life of the lamp and will render correct colour when balanced to daylight. When balanced to tungsten an orange (85B) filter is required to remove the excess blue cast these lights emit or by saving to RAW format. HMIs are used predominantly in the film industry and in studio car photography.

Flash (5800K)

Flash is a generic term referring to an artificial light source of high intensity and short duration. It will render correct colour when balanced to daylight. When balanced to tungsten an orange filter (85B) would be required to remove the blue cast. There is minimal heat output, and it maintains constant colour balance and intensity. To assess the direction and quality of the light flash heads have built-in tungsten modelling lamps. As the output and intensity of the flash is far greater than the modelling lamps, exposure times will be too short for any tungsten exposure to register.

Health and safety

Power supply

It cannot be stressed strongly enough that the lighting equipment and studio power supply be either installed, or checked in the case of existing supply, by a qualified and licensed electrician. Without question working with powered light sources is the most dangerous part of a photographer's job. As a photographer it is inevitable light sources are taken for granted and unfortunately familiarity leads to complacency and poor safety practices.

~ Electricity is dangerous. It can kill you.
~ Never attempt to repair lights or wiring unless you are absolutely confident you know what you are doing.
~ Always turn off the power and disconnect the cable before changing a globe.
~ Never touch any part of a light or cable with wet hands.
~ Exercise extreme care when photographing liquids.
~ Always turn off the power to the flash pack when changing flash head outlets.
~ Always be cautious when moving or connecting lights.
~ Never use liquids near electricity.
~ Use heat-resistant gloves when handling tungsten lights.
~ Wear shoes with rubber soles.
~ Ensure you know where and how to use the first aid kit.
~ Ensure you know where and how to use the fire extinguisher.
~ Ensure you are aware of emergency procedures related to work area.
~ Ensure adequate ventilation of the studio area.

Shaun Guest

Light sources

Tungsten

Vacuum tungsten lamps are widely used forms of artificial lighting in photography, film and television. They have a colour temperature between 3200 and 3400K. Despite the extensive use of flash in a commercial studio, prior to any flash exposure the way a subject is lit is determined by the tungsten modelling lamps built into the flash heads. Flash gives a much shorter exposure time and a comparable quality of light to tungsten. It should be taken into account when learning the use of tungsten light that all film and television lighting is tungsten based. Generally they all fall into two major categories, floodlight and spotlight.

Floodlight

A floodlight produces a spread of light across a subject. The light from the globe bounces off the reflector in which it sits and travels forward as a broad light source. This diffuse light gives 'soft' edges to the shadows and some shadow detail. The quality of the light is similar to that of sunlight through light cloud.

Kata Bayer

Spotlight

A spotlight can concentrate light at a certain point. The light is directed forward by a hemispherical reflector and focused to a point by a focusing (Fresnel) lens. The shadows will have 'hard' edges with no detail. The quality of the light is similar to direct sunlight. Spotlights can be flooded to give a more diffuse quality. This change from spot to flood is achieved by moving the lamp and the reflector inside the lamp housing away from (spot) or closer to (flood) the lens at the front of the light. On 'full spot' shadows are harsh with no detail, on 'full flood' shadows are softer with some detail. Most spotlights come with barn doors and nets. Barn doors are metal flaps attached to the front of the light and control the shape and amount of light. Nets are pieces of wire gauze of varying densities that reduce the output of the light by diffusing the light at its source without greatly affecting the shadows. They are manufactured in half and one stop increments.

Flash

Flash is a generic term referring to an artificial light source of high intensity and short duration. It has a colour temperature of 5800K, balanced to daylight and is compatible with daylight colour film and black and white film. Unlike tungsten it is not a continuous source of light. Between flashes it has to recycle (recharge) to maximum output before it can be used. Large tungsten lights have an output 100 times greater than the average household light. With a film rated at 100 ISO this will give exposures of around 1/60 second at f4. A modest studio flash with an output of 5000 joules (measurement of output) at the same distance from the subject as the tungsten light will give exposures of around 1/500 second at f11. This is six stops faster or a ratio of 64:1. Its advantage when photographing anything that moves is obvious.

Mick Downes

The advantage of modern flash is its lightweight construction and versatility. Most studio flash systems consist of a power pack, flash heads and attachments. The power pack is usually a separate unit where light output is stored until the instant of exposure. After exposure the power pack recharges ready for the next exposure. Recycling times vary from seconds to fractions of seconds. The faster the recharge to full power the more expensive the unit. The flash heads are the actual light source. The basis of their design is to produce light similar to that produced by floodlights and spotlights. The way in which this is achieved ranges from varying sizes of reflector bowls similar in design to a floodlight to a focusing spotlight equivalent to its tungsten counterpart. Flash, being a non-continuous light source, is generally confined to 'still' photography whereas tungsten lighting is used almost exclusively in 'moving' photography (film, video and TV). However, the lessons learned with one light source apply equally to any other.

ACTIVITY 1

Using various resource material compile a collection of studio photographs using tungsten or flash as a light source. Divide into the two categories.

Consider why a particular light source was used, its advantages and differences.

Floodlight

Swimming pool, soft box, fish fryer and others are names for variations of a floodlight. In some the light source is placed inside and to the rear of a collapsible tent with direct light transmitted through a diffuse front surface. In others the light is reflected off a white/silver surface before it is transmitted through a diffuse front surface. These sources create a very soft diffuse light with minimum shadows. Soft diffuse light is also created when flash is used in conjunction with a collapsible umbrella. With umbrellas having a white/silver inside surface, light can be directed into the umbrella and reflected back onto the subject creating a quality of light similar to a soft box. With umbrellas having a transparent diffuse surface light can be directed through the umbrella creating a quality of light less diffuse than the reflected light from the white/silver umbrella.

Tim Stammers

Spotlight

The use of an open flash (direct light to subject without diffusion or reflection) will give the same effect as a spotlight. Some brands have focusing capabilities closely imitating Fresnel spotlights. The light will be hard with no shadow detail. Barn doors, nets and filtration of the light source are approached in exactly the same way as a tungsten source.

Mixed light sources

Any source of light can be combined with another to create interesting lighting effects and shifts in colour balance. In a studio situation this can go beyond mixing tungsten with flash and is limited only by one's imagination. Normal domestic lamps are often used as supplementary and practical sources of light. Candles give a warm glow and very soft shadows. Torch light can be used to great effect when painting with light. When working in colour do not be afraid to change the colour of the light by the use of coloured gels over the lights or filtration of the camera. If it gives off light, try using it!

Mixed tungsten and flash - Fabio Sarraff

ACTIVITY 2

Place the camera on a tripod and attach cable release. Focus on a coin placed on a dark background. Set the shutter speed to T (aperture opens when the cable release is activated and will not close until activated for the second time). Set the aperture to maximum aperture. Darken the studio and open the lens. Using a small torch move its light over the coin as if painting with a brush (large broad strokes) for approximately 10 seconds. This should be done from the camera position.

Bracket exposures one stop either side of normal. Repeat this procedure at every f-stop.

Working with studio lights

Common rules

Common rules of physics apply to the use of artificial light sources. When sunlight passes through greater amounts of particles in the atmosphere at dawn or sunset, exposure times increase compared to a reading taken at noon. This applies to clear and overcast days. Exposure times will obviously be shorter on a clear day. Applying these rules to a studio situation, the greater the impedance to the light (diffusion, reflection, filtration) the longer the exposure. Direct light (no diffusion, reflection, filtration) the shorter the exposure.

Another simple rule. The amount of light falling on a subject decreases to 1/4 of its original intensity when the light to subject distance is doubled, and increases by 4x when the light to subject distance is halved. For example, if a reading of f16 is obtained when the light to subject distance is one metre, at two metres the reading would be f8, at four metres f4. These rules do not change regardless of the light source. It is also important to remember contrast in a studio situation is created not only by the reflectance level of the subject matter (SBR) but also by lighting ratios. When referring to lighting ratios the photographer is also referring to lighting contrast. See 'Contrast and Compensation'.

Key light one metre from subject

Key light two metres from subject
- Fabio Sarraff

ACTIVITY 3

In a darkened studio place a light one metre from the studio wall and take an incident reading, with the light on, of the light falling upon the wall. Note the reading and move the light on the same axis another one metre away from the wall. Note the reading. Double the distance once more, making a total of four metres. The final reading will be four stops less than the first. What will the distance of the light from the wall have to be to achieve a meter reading of three stops less than the first? Note in Record Book.

Diffusion

Long before the invention of photography painters had been diffusing light. Light passing through certain materials created a light with soft shadows sympathetic to their subjects. Early writings and drawings of Michelangelo show his studio had a type of cheesecloth hung over the windows. This diffused the harsh sunlight and filled the studio with a soft light more suitable to painting. Any light source can be diffused by placing certain translucent materials between the light source and the subject. This has the effect of diffusing and spreading the light over a greater area by altering the direction of the light waves. Diffusion softens the edges of the shadows and increases shadow detail. At the same time the measured amount of light falling on the subject is decreased. The amount of diffusion is also determined by where the diffusion material is placed in relation to the light source and the subject. The closer the diffusing material to the light source the less diffuse the light. The closer the diffusing material to the subject the more diffuse the light, the softer the edges of the shadows and the greater the shadow detail. There are many diffusion products manufactured specifically for the photographic market. These are products such as scrim, nets and silks. Other suitable materials are tracing paper, cheesecloth and window netting, provided they are non-flammable or heat-proof.

Itti Karuson

ACTIVITY 4

In a darkened studio light a semi-reflective object (e.g. a tomato) with an open flash or tungsten spotlight. Place the light approximately 1.5 metres from the subject.

Observe the source of light reflected in the object and lack of shadow detail.

Diffuse the light source with tracing paper (60cm x 60cm) 50cm from the light.

Observe the apparent increase in the size and diffusion of the light source as reflected in the subject, diffusion of the shadows and increase in shadow detail.

Without moving the light place the tracing paper as close to the subject as possible.

The light source has now become the size of the piece of tracing paper. There will be a soft spread of light over most of the subject with the shadow being almost non-existent.

Reflection

Reflected light is most often used as a way of lighting areas the dominant light source (key light) cannot reach. An example is the strong shadow created by a spotlight when it is to one side of the subject. To obtain detail in the shadow area light has to be reflected into the shadows. This is called fill light and is achieved by collecting direct light from the light source and redirecting it with a reflector. Reflectors can be any size, from a very small mirror to large polystyrene sheets measuring 3m x 1.5m.

Reflected light can also be used as the key light. When photographing a reflective object, or a very diffuse (soft) lighting effect is required, the light source can be directed into a reflector. The reflector becomes the light source and no direct light from the light source is directed at or reflected in the subject. When photographing cars in an exterior situation the car is usually positioned so sunrise or sunset is behind the car. With the sun below the horizon, the sky above and in front of the car is acting as a giant reflector. This is one approach to lighting cars and reflective objects in a studio.

There are many reflective products available manufactured specifically for the photographic market. Other more readily available materials are white card, grey card, coloured card, silver foil, aluminium foil and mirrors.

Reflector as light source - Stuart Wilson

ACTIVITY 5

Light a person's face with open flash or tungsten spotlight from behind and to one side.

Observe the deep shadows falling across most of the face.

Using a reflector (white card 1m x 1m) redirect the light into the shadow areas.

Observe how the intensity of the light changes as the reflector is moved closer to and further away from the face.

Expose image at the desired intensity of fill.

Cover the reflector with aluminium foil and repeat the above activity.

Label and keep results for future reference.

Compile results in your Record Book.

Filtration

Filters alter the quality of light by selectively transmitting certain colours or by changing the way light is transmitted. A red filter only transmits red light. A blue filter only transmits blue light and so on. A soft focus filter changes the direction of the light waves in the same way as diffusion material softens a light source. Correction filters alter the colour temperature of the light to make it compatible with the film being used. Neutral density filters reduce the amount of light, and therefore exposure, from a light source without affecting its colour temperature. Glass, plastic and gelatin filters are used for filtration of the camera lens but gelatin filters are used more often in the filtration of the light source. The advantage of filtering the light source is that different filters can be used on each of the lights whereas with filtering the camera all light entering the lens will be subjected to a common filter. Filters used upon a light source are made of heat-resistant coloured gels manufactured to specific safety requirements and colour balance. The effect of filtration is obvious and immediate. When working with correctly colour balanced gels, appropriately balanced film or image sensor and correct exposure 'what you see is what you get'. When using colour filtration with black and white film a simple way of remembering the effect of a certain filter is that it will lighten its own colour and darken all others. Filtration of the camera is normally used for colour correction of the entire image. This may be caused by the light source being incompatible with the film or to remove an excess of one colour inherent in the light source. However, when capturing RAW file images it is possible to undertake colour correction and in post production. See 'Characteristics of Light'.

Polarising filters are valuable in the control of unwanted reflections and increased colour saturation. This is because of their ability to selectively transmit certain wavelengths as they are rotated in front of the camera lens or light source. A wide range of 'effect filters' such as graduated and star burst are also available for on-camera use and post production software. They can produce some interesting results but should not be used as a substitute for the lack of an original idea or solution to a photographic problem. With camera filtration there will always be some degree of exposure compensation.

Post produced filtration - Itti Karuson

Lighting ratios

Light meters are often incorrectly called exposure meters. Exposure is only one part of its function. It can also be used for measuring lighting ratios. This is achieved by taking an incident reading of the light source from the subject. The meter is pointed at a specific light source to measure the amount of light falling on the subject. If there is more than one light source each light can be measured independently by ensuring only one light source is on at any one time. In this way the ratios between the light sources can be measured. Understanding and controlling lighting ratios will help ensure that the SBR is within the film/image sensor's latitude.

Lighting ratios and their relationship to film/sensor latitude is best demonstrated and understood at a practical level. Take, for example, a photographer using a film/sensor known to have a latitude of five stops. To make use of this information the photographer would try to light the subject to within this range. A five stop latitude would allow a photographer to use a maximum lighting ratio of 32:1 (five stops). This ratio would retain detail in the highlights and the shadows.

Example I

In a darkened studio a person is lit with a single light source from the right-hand side at 90 degrees to the subject. An incident light meter reading is taken from the right-hand side of the person's face directly towards the light source. The aperture is f45 at 1 second. An incident light meter reading is taken from the left-hand side of the person's face directly towards the opposite side of the studio to where the light is placed. The aperture is f4 at a shutter speed of 1 second. This is a lighting ratio of 128:1 (seven stops).

To reduce this ratio another light or a reflector (fill) is placed on the left-hand side of the subject. The fill is moved towards or away from the subject until an aperture reading no more than three stops lower in number than that from the main light source (f16) is obtained. This is now a lighting ratio of 8:1.

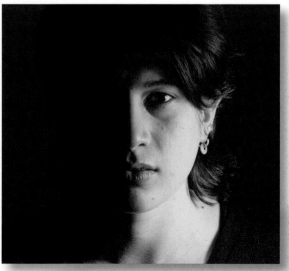

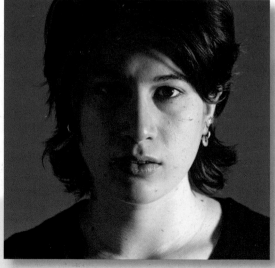

128:1 _8:1_

Example 2

The task is to light three sides of a single coloured box with a one stop ratio between each of the sides. Pointing a light meter in the general direction of the subject would give an average reflected reading for 'correct' exposure but would not indicate the difference in the light falling on each of the three sides. This can be achieved by taking either a reflected reading of each side or for a more precise measurement taking an incident reading of each of the three light sources. This would give a measure of the actual amount of light falling on the subject. This information can then be used to adjust the balance of the lights to achieve the required lighting ratio.

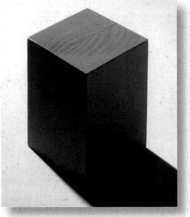 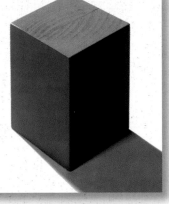

1. Spotlight 2. Spotlight + floodlight 3. Spot, flood + reflector

1. A point source (spotlight) is aimed at the top of a neutral grey box from behind the subject. The shadow falls forward of the subject. An incident reading is taken of the light source by pointing the invercone directly at the spotlight. The reading is f16.

2. A diffuse source (floodlight) is aimed at the left side of the box, ensuring no light affects the top or right side of the box. An incident reading is taken of the floodlight (shield the invercone with your hand to prevent light from the spotlight affecting the reading) by pointing the invercone directly at the floodlight. The reading is f11. This is a lighting ratio between the top and left-hand sides of 2:1 (one stop).

3. A piece of white card is used to reflect light back into the right-hand side of the box. The light reflected is gathered from the spotlight and floodlight. With both lights on, an incident reading is taken of the reflected light by pointing the invercone directly at the piece of white card. The reading is f8. This is a lighting ratio between the left and right sides of 2:1 (one stop), and an overall lighting ratio between the top and left-hand side of 4:1 (two stops).

An incident reading is taken by pointing the invercone from the front of the box back towards the camera. It should be f11. This is an average of the lighting ratio.

photographic lighting >>>

>>> essential skills >>>

Example 3

The task is to photograph a chain and a paper clip on a textured background. The lighting ratio between the most intense area of the background and the subject should be 8:1. The subject should be in focus, the background out of focus. The approach taken is the same as in Example 2, using incident light meter readings to control lighting ratios and exposure.

James Newman

Using a point source (key light) from the right and above the subject, light the staple and chain to create highlights along their top edge. Take an incident reading from the subject to the light source (e.g. f16). Place a diffuse light source (fill light) to the left of the subject. Between this light and the subject place a large sheet of tracing paper (the further the tracing paper from the light source the more diffuse the light. With the key light turned off take an incident reading from the subject to the diffuse light source. Move the light closer to or further away from the subject until a lighting ratio of 2:1 is achieved (e.g. f11).

Position background approximately one metre behind the staple and chain. Adjust the position of the key light to ensure no shadows from the chain fall on the background. Turn off key light and fill. Place a point source of light behind and to the right of the subject. Aim the light across the background to increase the texture of its surface. Adjust the light until the desired highlights are achieved. Take a reflected reading of the most intense highlight on the background. Adjust this reading by three stops to render the highlight white (e.g. f22 to f11). Move the light closer to or further away from the background until a reading equal to the average of the key light and fill is achieved (e.g. average of f16 and f11 = f11.5). Turn on key light and fill. Filter lights and/or camera for effect. Take an incident reading from the subject to the camera. Choose an exposure aperture with sufficient depth of field to retain focus on the staple and chain but not on the background.

Example 4

A photographer has to create a mid key portrait containing a predominance of average tones but with no extreme highlights or shadows. The result is achieved using a large, diffuse light source, creating a soft even lighting quality, combined with selective fill and overexposure by one stop to obtain correct skin tones. This is one of the most commonly used forms of portraiture lighting. It is a relatively simple approach to lighting the human form compared to high and low key lighting and will generally produce good results with most subjects. It does however lack drama and mood and would not enhance subjects with strong individual character, delicacy of form or great physique.

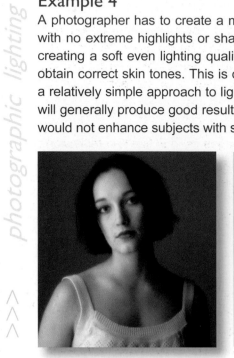
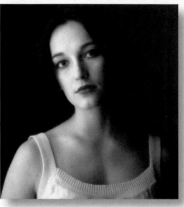

| 1. Soft box | 2. Soft box + fill | 3. Soft box + fill + back light |

1. Place the subject approximately two metres from a large diffusion screen (background). As viewed from the camera place a soft diffuse light source (flash soft box) in front of and to the left of the subject. Place a diffusion screen larger than the light source between the light source and the subject. The screen should be approximately one-third of the distance from the light to the subject. Take an incident light meter reading from the subject to the camera. A typical reading would be f11 at 1/250 second.

2. Place a large (2m x 3m) white reflector in front of and to the camera right side of the subject. This will reflect light from the key light source back onto the right side of the subject. Adjust the distance of the reflector from the subject until an incident light meter reading from the subject to the reflector is one stop less than the key light. This should be f8 at 1/250 second. This is a lighting ratio of 2:1 between the left and right sides of the face and when used for exposure will overexpose the left side of the face to reduce any skin imperfections.

3. Place behind the diffusion screen in the background a large diffuse light source (flash soft box). Direct the light through the diffusion screen straight back at the camera. Adjust the light source so an incident light meter reading taken from the subject to the background diffusion screen is two stops more than the incident reading of the subject to camera (f8 at 1/250 second). This background reading should be f16 at 1/250 second. If the subject exposure is set to f8 at 1/250 second the background will appear white.

On location

Studio lights need not be limited to the studio. They can be used on location in conjunction with ambient and existing daylight. With colour correction of the light source or camera to balance with the film/image sensor being used, most light sources can produce acceptable and interesting results. RAW file images can be colour corrected in post production. See 'Characteristics of Light'.

Exterior location

Common examples of studio lighting used on location are the images seen in film and television. The same approach can be taken to still images. Artificial light, whether flash or tungsten, is normally used to supplement the existing light present, usually daylight. In this situation correct colour is achieved by balancing to daylight tho film/image sensor (5500K) and filtering the tungsten light source/sources (3200K) with an 80A lighting gel. When using studio flash on location no filtration is required as the colour temperature of the flash is equal to average daylight (5500K).

Mixed light

Mixing the colour temperature of the light sources can give a more 'natural' look. Despite the fact the human eye corrects all light sources to what appears to be white light, it is visually accepted, and in most cases to great effect, when we view images created using mixed light sources that there should be a difference between the colour temperature of the various sources of light within the frame.

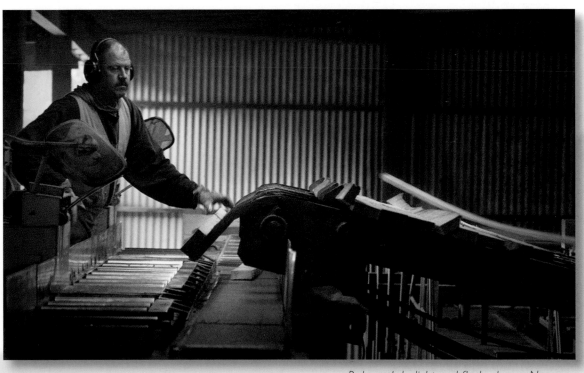

Balanced daylight and flash - James Newman

Example 5

A photographer has been commissioned to photograph the exterior of a restaurant complex situated in a vineyard. The client has requested there be equal interior and exterior detail. As the building is in constant use the client does not want any introduced lighting placed in the restaurant that may cause health and safety issues for his customers. To achieve this result the photographer decides to create the image by making two exposures, one for the exterior, another for the interior. The camera/film is balanced to daylight. This will record the practical interior lighting, predominantly commercial tungsten (orange/red) and fluorescent lighting (green), as a different colour temperature to the exterior daylight.

Exterior ambient light - incident - exposure MIE less 1/2 stop

Total darkness - interior lights on - reflected - exposure average highlights and shadows

Combination exposure - John Hay

Interior location

There can be many different light sources with varying colour temperatures confronting the photographer on location. This can range from industrial lighting to the glow from a TV. The possibilities and variations are many but the problems they pose can be either corrected with filtration or white balance adjustment to render 'correct' colour, or ignored and the differences in colour temperature exploited and used to effect.

Daylight balance

In an exterior location all light sources are balanced to the predominance of daylight (5500K). With an interior location (for example, a furnished room with large windows) there can be a mixture of various light sources. Balancing to daylight (5500K) without filtration of the tungsten light sources (3200K) would make the image appear quite different. Daylight in the image would appear 'correct' but any tungsten light source whether artificially introduced (studio) or practical (normal domestic lighting, desk lamps, candles, etc.) would create a warm glow at its source and on subject matter predominantly lit by it. The overall effect would be of white light through the windows, and depending upon the lighting ratio created between the tungsten light and the ambient daylight an overall warm cast to the image.

Tungsten balance

If the camera/film is balanced to tungsten (3200K) without filtration of either the daylight (5500K) or the tungsten light sources (3200K) the result would appear different again. Daylight in the image would appear to have a blue cast and any tungsten light source would appear 'correct'. The overall effect would be of blue light through the windows and, depending upon the lighting ratio created between the tungsten light and the ambient daylight, a balance of 'correct' colour within the room. It should be remembered filtration of the camera to match the dominant light source would also produce similar results. However, filtration of the camera removes the possibility of selectively filtering the various light sources and colour temperatures available to the photographer to create an interesting mix of colours within the frame.

Domestic tungsten light and daylight - James Newman

Example 6

A designer commissions a photograph of a kitchen. As it is in a residential building the owner has requested the minimum amount of disturbance. The client has requested the lighting enhances the space and balances ambient interior and exterior daylight. The photographer decides upon one exposure, balancing the exterior, interior and introduced lighting. The camera/film is balanced to daylight. Exterior daylight will be overexposed to reduce the orange/red colour cast of domestic tungsten lighting.

Ambient light - daylight and tungsten - incident - 1 sec .@ f8.5

Umbrella flash in hallway balanced to f8.5

Fill-flash off ceiling balanced to f8 - John Hay

Michel McFarlaine

creative techniques

Itti Karuson

essential skills

~ Develop knowledge and understanding of how light can change the
 character and mood of subject matter.
~ Develop skills in controlling lighting to achieve creative effect.
~ Observe the use of creative techniques in the production of photographic
 images.
~ Study an extensive collection of images utilising creative lighting
 techniques.
~ Produce photographic images demonstrating a practical understanding
 of creative lighting techniques.

Introduction

The choice, arrangement and design of a subject within the frame determines the effectiveness of its communication. Communication can be increased by having a better understanding of the camera and its controls. Careful consideration is advised when using technical effects. Images are about communication and content and not about technique. Technique should never dominate the image.

Exposure compensation

Exposure compensation is used to correct tonal values that would otherwise have recorded as too dark or too light. It is also used to record detail in highlights or shadows when the brightness range of the subject is high. Exposure compensation can also be used for creative effect. The creative process of photography sometimes requires an exposure that is not correct to produce the desired result. The degree of compensation is only limited by the photographer's imagination and the limitations of the film or image sensor. Interesting results can be achieved by purposely underexposing or overexposing regardless of SBR.

Mark Galer

Silhouettes

An image described as a silhouette is the dark shadow or outline of the subject against a lighter background. A silhouette can be created by backlighting the subject and reducing the exposure sufficiently to remove detail from the subject. Reducing the exposure by approximately two to three stops is usually required to record the subject as black.

Colour saturation

Decreasing exposure by 1/3 or 2/3 of a stop will increase colour saturation. This works especially well when using colour transparency as the processed image is viewed by light being transmitted through the film. The technique works well in flat midday light. Images can look underexposed if the photographer is recording tones of known value.

Backlighting

A subject is back-lit when the dominant light is from behind the subject. To take a reflected reading of the subject from the camera would give an incorrect exposure. A reflected reading of the subject only or an incident reading from the subject to the camera would give correct exposure. The dominance of the backlight can therefore be controlled by exposure compensation.

Haloes

With subjects having an extreme contrast either as a result of SBR or lighting ratios, exposing for the shadow areas will create the effect of massively overexposing the highlights. On its own or combined with lens filtration (soft filter) the result, especially when using a strong backlight, is a halo effect around the subject.

Natarsha Gleeson

ACTIVITY 1

Create the effect of a halo using a dominant backlight and exposure compensation.
Repeat the procedure to create two silhouettes with an interesting profile. One silhouette should have a white or clear background, the second the colours of an evening sky.
Bracket the reduced exposure compensation for each and label the results.
Process the images and label the results of each frame.

Low key

A low key image is where the dark tones dominate the photograph. Small bright highlights punctuate the shadow areas creating the characteristic mood of a low key image. The position of the light source for a typical low key image is behind the subject or behind and off to one side, so that the deep shadows are created. Appropriate exposure usually centres around how far the exposure can be reduced before the highlights appear dull. The shadow areas are usually devoid of detail when this action is taken unless a certain amount of fill is provided.

Janette Smith

High key

A high key image is where light tones dominate. Dark tones are eliminated or reduced by careful choice of the tonal range of the subject matter. Soft diffused lighting from a broad expansive light source is used to reduce shadows. Backgrounds may be flooded with light so that little detail is seen. Increased exposure ensures the tones are predominantly light. Hard edges and fine detail may be reduced by the use of a soft focus filter. A bright background placed close to the subject may also soften the outline of the form. The main light source to illuminate the subject can be provided by skylight, window light or light reflected off a large bright surface. Backgrounds can be overexposed by sunlight.

ACTIVITY 2

Create one high key and one low key image.

Describe the lighting used for each image including a record of the indicated exposure and degree of compensation.

Illusion of movement

Closely associated with an understanding of the use of light is the use of the camera to create the illusion of movement. By combining the movement of either the camera, subject or lights, the illusion of movement within a still frame can be created. Using tungsten light in a darkened studio and with the camera lens open, walking slowly through frame (the camera's field of view) will result in a blurred image where you were moving and still image where you stopped. Another way to create movement is to increase exposure time to the longest possible with the light source you are using and move the camera during all or part of the exposure. This is easily achieved with a zoom lens, but also achievable by panning or tilting the camera mounted on a tripod. There are other advantages to using a slow shutter speed when using a combination of flash and tungsten. If the output of the modelling lamps, or supplementary tungsten lighting, is high enough to equal the exposure aperture of the flash output a slower exposure time can be used for the tungsten light than required for the flash. This would allow correct exposure of the flash (which is regulated by aperture and not time) and correct exposure of the tungsten (which is regulated by a combination of aperture and time). This would give the effect when using daylight film/balance of a warm afterglow to any object moving before or after the flash exposure.

Itti Karuson

ACTIVITY 3

In a darkened studio light a person with a diffuse light source close to camera.
Set the shutter to the longest exposure time relative to the exposure aperture.
With the lens open ask the subject to walk across frame. Vary the speed and rhythm of the movement. Observe the images and compile results.

Daniel Willmott

photographic lighting >>> >>>

essential skills >>>

Samantha Everton

Tim Stammers

assignments

Spiro Alexopoulos

essential skills

~ Develop, extend and apply your knowledge and understanding of studio and location lighting, filtration and camera technique.

~ Develop, extend and apply your knowledge and understanding of the practical use of light to create contrast, dimension, mood.

~ Increase your creative ability to interpret a written brief within specific guidelines.

~ Through further study, observation and pre-production understand the resources and skills required to produce high quality photographic images.

~ Produce a series of images to the highest standard fulfilling the assignment criteria plus personal creative interpretation.

Introduction

The assignments in this study guide should be attempted after successful completion of the activities in the previous study guides. Creative interpretation of the written brief is strongly encouraged. Assignments should be completed at an individual level in any order. Allowance should be made for the fact that each assignment may need photographing more than once before a satisfactory result is achieved. Group tutorials should be the forum where technique and creative interpretation are discussed amongst students and lecturers. Special attention should be taken of the medium in which the photograph is to be used. This will determine image format and in some cases composition. See *Essential Skills: Studio Photography (Art Direction)*.

Samantha Everton

This series of images should portray an understanding of what lighting and camera technique can achieve in changing the photographer's perception of the subject and previsualisation of the image. Avoid placing a subject on or against a background, taking a normal viewpoint and perspective and lighting for correct colour and exposure. This is no different to documentation of the subject. As creative photographic illustrators much more is required. Experiment with viewpoint and lighting. Do not let reality get in the way of creative composition. Perspective, depth and dimension can all be altered to suit the design of the image. The camera will 'see' and record anything you want it to. This does not have to relate to human perception. Separate subjects from the background. Dispense with the concept of backgrounds altogether. The area behind and around the subject is only limited by your imagination. Previsualise, experiment and create.

Practical assignments

1. Still life

Subject of your choice photographed at an interior location, making use of filtration and the available ambient light. Any window and practical tungsten light source (desk lamp, etc.) should appear in the photograph. To be used for a single-page colour advertisement.

2. Formal portrait

Subject of your choice photographed on location (exterior or interior) making use of artificial tungsten light or studio flash. Horizontal format suitable for exhibition.

3. Time of day

Recreate in the studio an exterior photograph of a typical coffee restaurant table setting. The time of day is either early morning (breakfast menu) or late afternoon. Use colour filtration of the light source (flash or tungsten) to achieve the colour balance appropriate to the time of day. To be used for single-page colour editorial.

4. Available light

A still life of a vase of flowers photographed on location (interior or exterior) using only the available light. It should be photographed in the style of an impressionist painting. Format and film choice appropriate to the subject matter and desired effect.

5. Crowded street

A series of photographs of a single person in a crowded street to highlight the fact they are different to everyone else. Use should be made of a long focal length lens, selective focus and ambient light. Colour double-page spread.

6. Environmental portrait

A series of environmental portraits of people at work, rest or play for an international confectionery manufacturer. The people must be young, from various ethnic backgrounds and must always appear to be enjoying themselves. Use a mixture of available and supplementary lighting. Colour point of sale.

7. Product shot

Studio product shot to complement the previous series of portraits. The product should be obvious, yet sympathetic to the mood created by the portraits. Colour image.

8. Torchlight

Using torchlight only, light a subject of your choice in the studio or on location. Experimentation with exposure and filtration is required to achieve a satisfactory result.

Tim Barker

Itti Karuson

Glossary

1K	1000 watts, measure of light output.
2K	2000 watts, measure of light output.
5K	5000 watts, measure of light output.
10K	10,000 watts, measure of light output.
12K	12,000 watts, measure of light output.
120	Film format.
2 ¼	2 ¼ x 2 ¼". Camera format.
35mm	Camera and film format (24 x 36mm).
500W	500 watts, measure of light output.
5 x 4	5 x 4", camera and film format.
6 x 4.5	6 x 4.5cm camera format.
6 x 6	6 x 6cm camera format.
6 x 7	6 x 7cm camera format.
6 x 8	6 x 8cm camera format.
6 x 9	6 x 9cm camera format.
10 x 8	10 x 8 inches camera and film format.
80A	Conversion filter, daylight film to 3200K light source.
80B	Conversion filter, daylight film to 3400K light source.
85B	Conversion filter, tungsten film to daylight.
AC discharge	5600K continuous light source.
Ambient	Available or existing light.
Analyse	To examine in detail.
Aperture	Lens opening controlling intensity of light entering camera.
Arri 650W	Arriflex 650 watt light source (3200K).
ASA	Film speed rating - American Standards Association.
Auto focus	Automatic focusing system, mainly small-format cameras.
Available	Ambient or existing light.
B	Shutter speed setting for exposures in excess of 1 second.
B/g	Background.
Background	Area behind main subject matter.
Backlight	Light source directed at the subject from behind.
Backlit	A subject illuminated from behind.
Balance	A harmonious relationship between elements within the frame.
Banding	Visible steps of tone or colour in the final image due to a lack of tonal information in a digital image file.
Barn doors	Metal shutters attached to light source.
Bellows	Light proof material between front and rear standards.
Bellows extension	When length of bellows exceeds focal length of lens.
Bellows formula	Mathematical process to allow for loss of light.

Blurred	Unsharp image, caused by inaccurate focus, shallow depth of field, slow shutter speed, camera vibration or subject movement.
Bounce	Reflected light.
Bracketing	Overexposure and underexposure either side of MIE.
C stands	Vertical stand with adjustable arm.
C-41	Negative film process.
Cable release	Device to release shutter, reduces camera vibration.
Camera	Image capturing device.
Camera RAW	Unprocessed image data from a camera's image sensor.
Camera shake	Blurred image caused by camera vibration during exposure.
Close down	Decrease in aperture size.
Closest point of focus	Minimum distance at which sharp focus is obtained.
Colour balance	Photoshop adjustment feature for correcting a colour cast in a digital image file.
Colour conversion	Use of filtration to balance film to light source.
Colour correction	Use of filtration to balance film to light source.
Colour temperature	Measure of the relationship between light source and film.
Compensation	Variation in exposure from MIE to obtain appropriate exposure.
Complementary	Colour - see Primary and Secondary.
Compound	In lens design, indicating use of multiple optical elements.
Compression	Underdevelopment allowing a high-contrast subject brightness range to be recorded on film. See 'The Zone System'.
Concept	Idea or meaning.
Context	Circumstances relevant to subject under consideration.
Contrast	The difference in brightness between the darkest and lightest areas of the image or subject.
Cord	Electrical lead.
Covering power	Ability of a lens to cover film format with an image.
CPU	Central processing unit of a camera used to compute exposure.
Cropping	Alter image format to enhance composition.
Cut-off	Loss of image due to camera aberrations.
Cutter	Device used to control spread and direction of light.
Cyclorama	Visually seamless studio.
Darkcloth	Material used to give a clearer image on ground glass.
Dark slide	Cut film holder.
Daylight	5500K.
Dedicated flash	Flash regulated by camera's exposure meter.
Dense	Overexposed negative, underexposed positive.
Density	Measure of the opacity of tone on a negative.
Depth of field	Area of sharpness variable by aperture or focal length.

Depth of focus	Distance through which the film plane moves without losing focus.
Design	Basis of visual composition.
Diagonal	A line neither horizontal nor vertical.
Diaphragm	Aperture.
Differential focusing	Use of focus to highlight subject areas.
Diffuse	Dispersion of light (spread out) and not focused.
Diffuser	Material used to disperse light.
Digital	Images recorded in the form of binary numbers.
Digital image	Computer generated image created with pixels, not film.
DIN	Film speed rating - Deutsche Industrie Norm.
Dioptres	Close-up lenses.
Direct light	Light direct from source to subject without interference.
Distortion	Lens aberration or apparent change in perspective.
Double dark slide	Cut film holder.
Dynamic	Visual energy.
DX coding	Bar coded film rating.
E-6	Transparency film process.
Ecu	Extreme close-up.
Electronic flash	Mobile 5800K light source of high intensity and short duration.
Emulsion	Light-sensitive coating on film or paper.
Equivalent	Combinations of aperture and time producing equal exposure.
EV	Numerical values used in exposure evaluation without reference to aperture or time.
Evaluate	Estimate the value or quality of a piece of work.
Expansion	Manipulating the separation of zones in B & W processing.
Exposure	Combined effect of intensity and duration of light on light-sensitive material.
Exposure factor	Indication of the increase in light required to obtain correct exposure.
Exposure meter	Device for the measurement of light.
Exposure value	Numerical values used in exposure evaluation without reference to aperture or time.
Extreme contrast	Subject brightness range that exceeds the film's ability to record all detail.
F-stop	Numerical system indicating aperture diameter.
Fall	A movement on large-format camera front and rear standards.
Fast film	Film with high ISO, can be used with low light levels.
Field of view	Area visible through the camera's viewing system.
Figure and ground	Relationship between subject and background.
Fill	Use of light to increase detail in shadow area.
Fill-flash	Flash used to lower the subject brightness range.

Film	Imaging medium.
Film speed	Rating of film's sensitivity to light.
Filter	Optical device used to modify transmitted light.
Filter factor	Number indicating the effect of the filter's density on exposure.
Flare	Unwanted light entering the camera and falling on film plane.
Flash	Mobile 5800K light source, high intensity, short duration.
Floodlight	Diffuse tungsten light source.
Focal	Term used to describe optical situations.
Focal length	Lens to image distance when focused at infinity.
Focal plane	Where the film will receive exposure.
Focal plane shutter	Shutter mechanism next to film plane.
Focal point	Point of focus at the film plane or point of interest in the image.
Focusing	Creating a sharp image by adjustment of the lens to film distance.
Fog/fogging	Effect of light upon unexposed film.
Foreground	Area in front of subject matter.
Format	Camera size, image area or orientation of camera.
Frame	Boundary of composed area.
Fresnel	Glass lens used in spotlight.
Front light	Light from camera to subject.
Front standard	Front section of large-format camera.
Gels	Colour filters used on light sources.
Genre	Style or category of photography.
Gobos	Shaped cutters placed in front of light source.
Grain	Particles of metallic silver or dye which make up the film image.
Grey card	Contrast and exposure reference, reflects 18% of light.
Ground glass	Viewing and focusing screen of large-format camera.
Guide number	Measurement of flash power relative to ISO and flash to subject distance.
Halftone	Commercial printing process, reproduces tone using a pattern of dots printed by offset litho.
Hard/harsh light	Directional light with defined shadows.
High key	Dominant light tones and highlight densities.
Highlight	Area of subject giving highest exposure value.
Histogram	A graphical representation of a digital image indicating the pixels allocated to each level of brightness.
Hot shoe	Mounting position for on-camera flash.
Hyperfocal distance	Nearest distance in focus when lens is set to infinity.
Image sensor	Light-sensitive digital chip used in digital cameras.
Incandescent	Tungsten light source.

Incident	Light meter reading from subject to camera using a diffuser (invercone).
Infinity	Point of focus where bellows extension equals focal length.
Infrared film	A film sensitive to wavelengths of light longer than 720nm invisible to the human eye.
Invercone	Trademark of Weston. Dome-shaped diffuser used for incident light meter readings.
Inverse square law	Mathematical formula for measuring the fall-off (reduced intensity) of light over a given distance.
Iris	Aperture/diaphragm.
ISO	Film speed rating - International Standards Organisation.
JPEG (.jpg)	Joint Photographic Experts Group. Popular image compression file format used for images destined for the World Wide Web.
Key light	Main light source relative to lighting ratio.
Laboratory	Film processing facility.
Landscape	Horizontal format.
Large format	5 x 4inch camera, 10 x 8inch camera.
Latitude	Film's ability to record the brightness range of a subject.
Lens	Optical device used to bring an image to focus at the film plane.
Lens angle	Angle of lens to subject.
Lens cut-off	Inadequate covering power.
Lens hood	Device to stop excess light entering the lens.
Light	The essence of photography.
Lightbox	Transparency viewing system.
Lighting contrast	Difference between highlights and shadows.
Lighting grid	Studio overhead lighting system.
Lighting ratio	Balance and relationship between light falling on subject.
Light meter	Device for the measurement of light.
Long lens	Lens with a reduced field of view compared to normal.
Loupe	Viewing lens.
Low key	Dominant dark tones and shadow densities.
Luminance range	Range of light intensity falling on subject.
M	Flash synchronisation setting for flash bulbs.
Macro	Extreme close-up.
Matrix metering	Reflected meter reading averaged from segments within the image area. Preprogrammed bias given to differing segments.
Maximum aperture	Largest lens opening, smallest f-stop.
Medium format	6 x 7cm, 6 x 6cm, 6 x 4.5cm.
Meter	Light meter.

MIE	Meter indicated exposure.
Minimum aperture	Smallest lens opening, largest f-stop.
Monorail	Support mechanism for large-format camera.
Multiple exposure	More than one exposure on the same piece of film.
ND	Neutral density filter.
Negative	Film medium with reversed tones.
Negatives	Exposed, processed negative film.
Neutral density	Filter to reduce exposure without affecting colour.
Non-cord	Flash not requiring direct connection to shutter.
Normal lens	Perspective and angle of view approximately equivalent to the human eye.
Objective	Factual and non-subjective analysis of information.
Opaque	Does not transmit light.
Open up	Increase lens aperture size.
Orthochromatic	Film which is only sensitive to blue and green light.
Overall focus	Image where everything appears sharp.
Overdevelopment	When manufacturer's processing recommendations have been exceeded.
Overexposure	Exposure greater than meter indicated exposure.
Panchromatic	Film which is sensitive to blue, green and red light.
Panning	Camera follows moving subject during exposure.
Perspective	The illusion of depth and distance in two dimensions. The relationship between near and far imaged objects.
Photoflood	3400K tungsten light source.
Photograph	Image created by the action of light and chemistry.
Plane	Focal plane.
Polarising filter	A filter used to remove polarised light.
Portrait	Type of photograph or vertical image format.
Positive	Transparency.
Posterisation	Visible steps of tone or colour in the final image due to a lack of tonal information in a digital image file.
P.o.v.	Point of view.
Preview	Observing image at exposure aperture.
Previsualise	The ability to decide what the photographic image will look like before the exposure.
Primary	The colours, blue, green and red.
Process	Development of exposed film.
Pull	Under-processing of film.
Push	Over-processing of film.
QI	Quartz iodine light source.

RAW	The unprocessed data recorded by a digital image sensor. Sometimes referred to as camera RAW or the 'digital negative'.
Rear standard	Rear section of large-format camera.
Reciprocity failure	Inability of film to behave predictably at exposure extremes.
Reflectance	Amount of light from a reflective surface.
Reflectance range	Subject contrast measured in even light.
Reflected	Light coming from a reflective surface.
Reflection	Specular image from a reflective surface.
Reflector	Material used to reflect light.
Refraction	Deviation of light.
Resolution	Optical measure of definition, also called sharpness.
Reversal	Colour transparency film.
Rim light	Outline around a subject created by a light source.
Rise	A movement on large-format camera front and rear standard.
Saturation	Intensity or richness of colour.
SBR	Subject brightness range, a measurement of subject contrast.
Scale	Size relationship within subject matter.
Scrim	Diffusing material.
Secondary	Complementary to primary colours, yellow, magenta, cyan.
Selective focus	Use of focus and depth of field to emphasise subject areas.
Shadow	Unlit area within the image.
Sharp	In focus.
Shutter	Device controlling the duration (time) of exposure.
Shutter-priority	Semiautomatic exposure mode. The photographer selects the shutter and the camera sets the aperture automatically.
Shutter speed	Specific time selected for correct exposure.
Side light	Light from side to subject.
Silhouette	Object with no detail against background with detail.
Slave	Remote firing system for multiple flash heads.
Slide	Transparency usually 24 x 36mm.
Slow film	Film with reduced sensitivity and low ISO rating.
SLR	Single lens reflex camera; viewfinder image is identical to image captured by film or image sensor.
Small format	35mm.
Snoot	Cone-shaped device to control the spread of light.
Softbox	Heavily diffuse light source.
Soft light	Diffuse light source with ill-defined shadows.
Specular	Highly reflective surfaces.
Speed	ISO rating, exposure time relative to shutter speed.
Spotlight	Light source controlled by optical manipulation of a focusing lens.
Spot meter	Reflective light meter capable of reading small selected areas.
Standard lens	Perspective and angle of view equivalent to the eye.

Stock	Chosen film emulsion.
Stop	Selected lens aperture relative to exposure.
Stop down	Decrease in aperture size.
Strobe	5800K light source.
Studio	Photographic workplace.
Subject	Main emphasis within image area.
Subjective	Interpretative and non-objective analysis of information.
Subject reflectance	Amount of light reflected from the subject.
Swing	A movement on large-format front or rear standards.
Symmetrical	Image balance and visual harmony.
Sync	Flash sychronisation.
Sync lead	Cable used to synchronise flash.
Sync speed	Shutter speed designated to flash.
T	Shutter speed setting for exposures in excess of 1 second.
T-stop	Calibration of light actually transmitted by a lens.
Text	Printed word.
Thin	Overexposed positive, underexposed negative.
Thyristor	Electronic switch used to control electronic flash discharge.
TIFF	Tagged Image File Format. Popular digital image file format for desktop publishing applications.
Tilt	A movement on large-format front or rear standards.
Time	Shutter speed, measure of duration of light.
Time exposure	Exposure greater than 1 second.
Tonal range	Difference between highlights and shadows.
Tone	A tint of colour or shade of grey.
Trace	Material used to diffuse light.
Transmitted light	Light that passes through another medium.
Transparency	Positive film image.
Transparent	Allowing light to pass through.
Tripod	Camera support.
Tripod clamp	Device used to connect camera to tripod.
TTL	Through the lens light metering system.
Tungsten	3200K light source.
Typeface	Size and style of type.
Typography	Selection of typeface.
Underdevelopment	When manufacturer's processing recommendations have been reduced.
Uprating film	Increasing the film speed.
UV	Ultraviolet radiation invisible to the human vision.
Vertical	At right angles to the horizontal plane.
Viewpoint	Camera to subject position.

Visualise	Ability to exercise visual imagination.
Wide angle	Lens with a greater field of view than normal.
X-synch.	Synchronisation setting for electronic flash.
X-synch. socket	Co-axial socket on lens or camera for external flash cable.
Zone system	Exposure system related to tonal values.

Index

photographic lighting

>>> essential skills >>>

photographic lighting

>>> essential skills >>>

photographic lighting

>>> >>> essential skills >>>

study
Photography

@

RMIT
UNIVERSITY

Study photography online.
13-week modules from beginners to advanced.
Undergraduate equivalent courses supported by
interactive online classrooms, experienced lecturers
and Internationally published RMIT texts.

www.rmit.edu.au/adc/photography/online